夕陽餘暉

SUNSET SURVIVORS

MEET THE PEOPLE KEEPING HONG KONG'S TRADITIONAL INDUSTRIES ALIVE

LINDSAY VARTY

PHOTOGRAPHY BY GARY JONES

ISBN 978-988-77928-3-3

Published by Blacksmith Books
Unit 26, 19/F, Block B, Wah Lok Industrial Centre
37-41 Shan Mei Street, Fo Tan, Hong Kong
Tel: (+852) 2877 7899
www.blacksmithbooks.com

Design and typesetting by Power Point Creative Ltd.
Unit B, 8/F, Camel Paint Building Block 3
60 Hoi Yuen Road, Kwun Tong, Kowloon, Hong Kong
Tel: (+852) 2504 3911
www.powerpointcreative.com

Front Cover: Luk Shu Choi and Luk Keung Choi, Craftsmen at Bing Kee Copperware

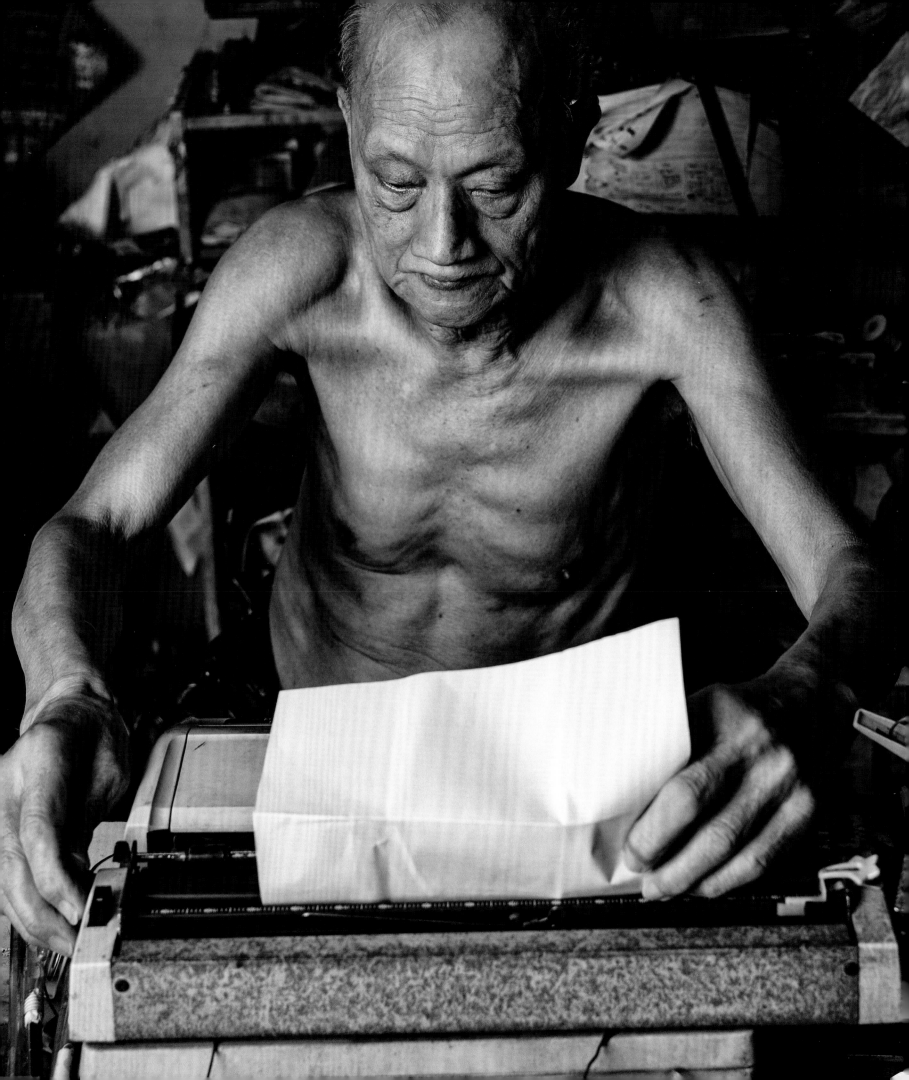

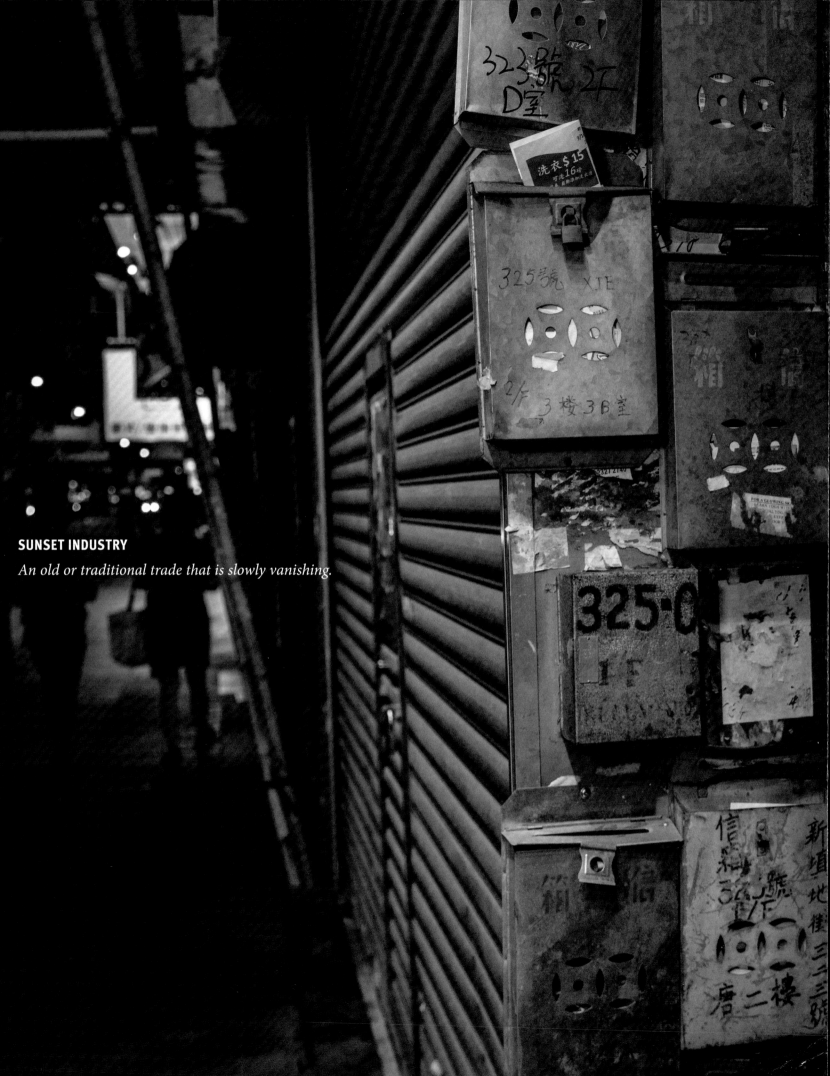

SUNSET INDUSTRY

An old or traditional trade that is slowly vanishing.

INTRODUCTION

By Lindsay Varty

n the heart of Central, amid the hordes of iPhone-wielding workaholics and billion-dollar shop windows, stands an elderly Chinese man. Dressed in a shabby linen shirt, he sells sweet-smelling white flowers to slip into your top pocket: a simple adornment of a bygone era.

It was this very man, in all his gentle stoic charm, who inspired the writing of this book and the need to document Hong Kong's dwindling cultures amid the electrifying pace of modern society. This simple encounter led to the discovery of dozens of other street-savvy, traditional entrepreneurs who have devoted their entire lives to ancient and increasingly forgotten practices.

It became quickly evident that these tenacious tradesmen and women – however clandestine against the frantic urban backdrop – were essential ingredients in Hong Kong's cultural identity. Their fascinating lives, hard-worn hands and steadfast expressions have been the base on which a modern metropolis has been built.

But with almost no willing successors, little chance of competing with larger companies and skyrocketing rents, simply surviving this metamorphosis has proven almost impossible. And so, as these sunset survivors continue to slowly pass away, so too will a unique slice of Hong Kong's history and character. This book hopes to capture a glimpse of the hardy few who have battled the odds and continue to run their businesses today.

FOREWORD

By Jason Wordie, Hong Kong Historian and Author

From Japan and China to South East Asia, the Indian sub-continent, the Middle East and across Africa, the rapid advance of modernity, closely allied to steadily rising material prosperity and enhanced educational and employment opportunities for the previously marginalised – particularly women, children and minority groups – has meant that long-established trades and crafts – some of them centuries old – and the various occupations that deployed these skill sets, have steadily disappeared.

Traditional trades and crafts are among the modern world's most endangered species; but unlike other extinctions, where "lost" means gone forever, antiquated skill-sets, once discarded, can be painstakingly revived with sufficient incentive. But once resuscitated, few revivals ever seem quite the same again. In their artificially induced second life, traditional trades and crafts too often become just another commercial commodity kept hollowly alive by nostalgia-themed marketing, and the various – and all too often, conflicting – demands of today's burgeoning "heritage" industry.

Hong Kong is no exception to this global trend, and locally, the process seems set to continue even more in coming years. Constant pressure directly caused by spiralling property prices and shop rents have a catastrophic knock-on effect for businesses with a small profit margin, especially in urban locations – Hong Kong Island's Western District is an immediately obvious example, though the trend is readily observable right across the city – where gentrification has become rampant.

When a traditional business is owner-operated, the temptation to retire and comfortably live on the rent of a small back-street shop, instead of continuing to brew rice wine, construct lanterns, or thread beaded sandals, becomes an economically logical, if personally saddening, inevitability. This ongoing trend can be witnessed right across contemporary Hong Kong.

When Hong Kong's older generations of skilled artisans finally hang up their tools and retire, their younger generation of family members seldom replaces them. And why would they? The aspiration of their forebears was for their descendants to go on to something "better" – which in practice meant an occupation that was higher-status, less physically demanding, and far better paid. Only those who can afford – somehow – to pursue these trades as a "lifestyle" job, rather than a genuine source of income, will willingly take up the mantle of a family business, somehow forge a creative reinvention of both the enterprise and themselves, and go on into the future.

In consequence, some threatened skill-sets continue to enjoy renewed lives in revitalised settings. From back-street paper makers, soy-sauce, bean-paste and chilli-oil manufacturers and old-fashioned bakeries to shoe-makers and tailor shops, long-established businesses "go artisanal" and artfully repackage their products to appeal to the changing tastes and – all too often – the imagined nostalgia, of a different generation. These spontaneous reactions against the stultifying blandness of globalised conformity can help give some once-threatened trades and their array of products a fresh lease on life, and gives the phrase "new wine in old skins" an entirely new and welcome local dimension.

Tradition, anywhere in the world, is never static, and Hong Kong is no exception; today's unusual innovation becomes hallowed by time and exposure into a traditional custom two generations later, or even less. Some age-old trades, crafts and occupations, however, die a natural death, and their end – while worth noting – is best unlamented.

Among the most obvious of such disappearances are Hong Kong's long-vanished rickshaws and sedan chairs. Picturesque and reminiscent of another era though these may be to those only accustomed to motor transport, they are nevertheless a reminder of a time, not so long ago, when backbreaking human labour – and the impoverished people who provided it – was cheaper, more exploitable and more disposable than costly machinery.

No longer can rickshaws and sedan chairs be seen in urban Hong Kong, and their complete loss – because unskilled manual workers of a younger generation, who once would have had little option but to spend their entire lives toiling before the shafts, now have alternative and far better sources of income – is something to be widely celebrated rather than mourned.

And widespread celebration is what this marvellous book and its talented author have done best. A Hong Kong girl with several generations of local personal heritage from which to draw inspiration, Lindsay Varty must be commended for assembling this excellently produced, well-researched and timely record of her home town's ongoing evolution and change.

Sunset Survivors will be an excellent record and resource for the future, as well as a fascinating, at times poignant work to be enjoyed by the present generation of Hong Kong people, and visitors to the city, who are fortunate enough to get a lingering glimpse – just – at these fascinating trades and crafts, and the people who produce them. It gives me great pleasure to commend this, worthwhile, eminently readable book.

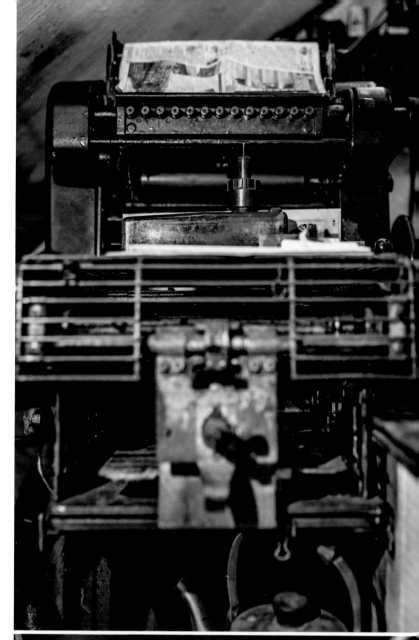

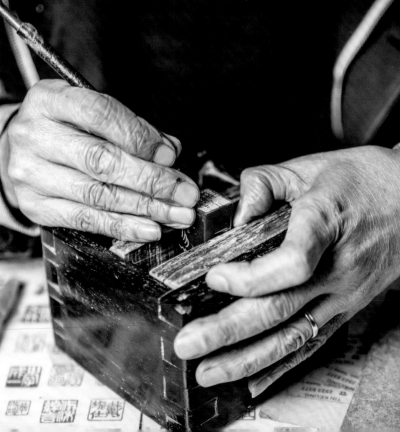

CONTENTS

RAYMOND LAM 林應鴻
OWNER OF TUCK CHONG SUM KEE BAMBOO STEAMER COMPANY
德昌森記蒸籠

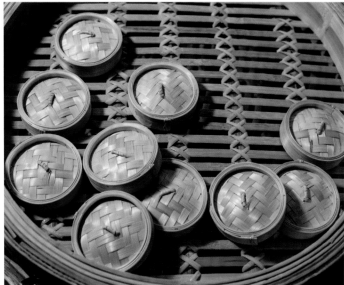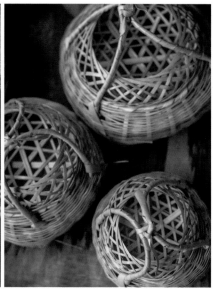

The Tuck Chong Sum Kee Bamboo Steamer Company is the last remaining traditional business of its kind in Hong Kong. Each item in the crowded narrow shop is handcrafted by a member of the Lam family, who moved to the city in the 1950s. Raymond Lam started working in the shop as a young boy and by the time he graduated he could make the steamers himself. Mr Lam still spends every day carefully moulding the bamboo into the round-shaped steamers, which house the beloved Chinese dim sum. The key to a great steamer, he says, is knowing the softness and texture of each piece of bamboo, which imparts a unique smell and taste on the food inside. Mr Lam's trademark stamp can be seen on steamers in local dai pai dongs and restaurants across the city. But he suspects others are making counterfeit copies of his work and is concerned about his reputation and the survival of his business.

"HANDICRAFT BUSINESSES HAVE ALWAYS BEEN SEEN AS JOBS FOR PEOPLE WITH POOR EDUCATION. WITH THE IMPROVING EDUCATION LEVELS IN THE COMMUNITY, FEWER PEOPLE ARE WILLING TO LEARN THESE SKILLS OR ENTER OUR INDUSTRY."

"IF THE DAY COMES WHEN HONG KONGERS NO LONGER ENJOY YUM CHA, THAT'S THE DAY OUR CULTURE IS DEAD AND I'D PROBABLY CLOSE THE SHOP."

THE INDUSTRY

It is no secret that Hongkongers love their dim sum. The traditional bite-sized delights just would not be the same without their signature bamboo steamer. Bamboo has long been used in China to produce household goods, but none more iconic than the steamers. The material is naturally antibacterial, heat and mould resistant, light, inexpensive and perfectly absorbs excess water from the steaming process. Though demand is certainly not waning – Hongkongers' love for dim sum is still going strong – China's cheap labour costs and access to bamboo now means that the production of these steamers has almost entirely moved to mainland factories. Hong Kong's once thriving industry is almost entirely extinct – all except for the Tuck Chong Sum Kee Bamboo Steamer Company.

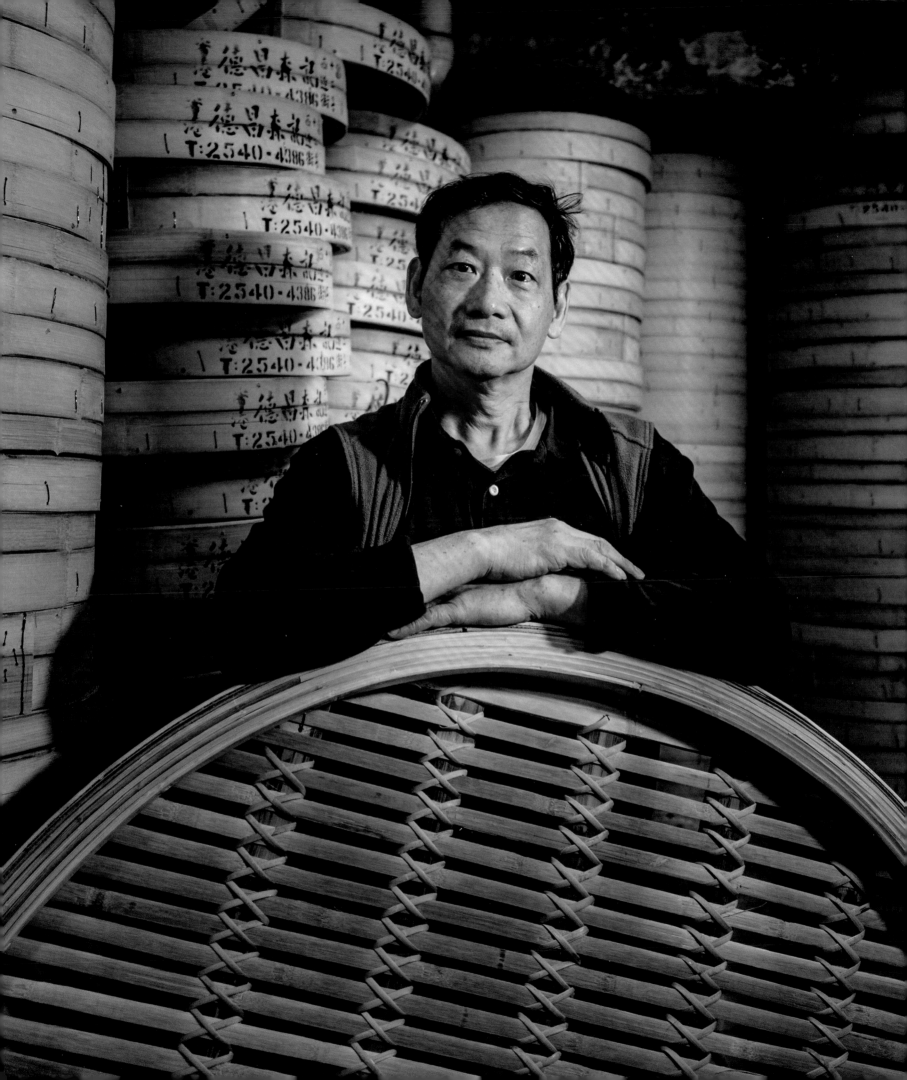

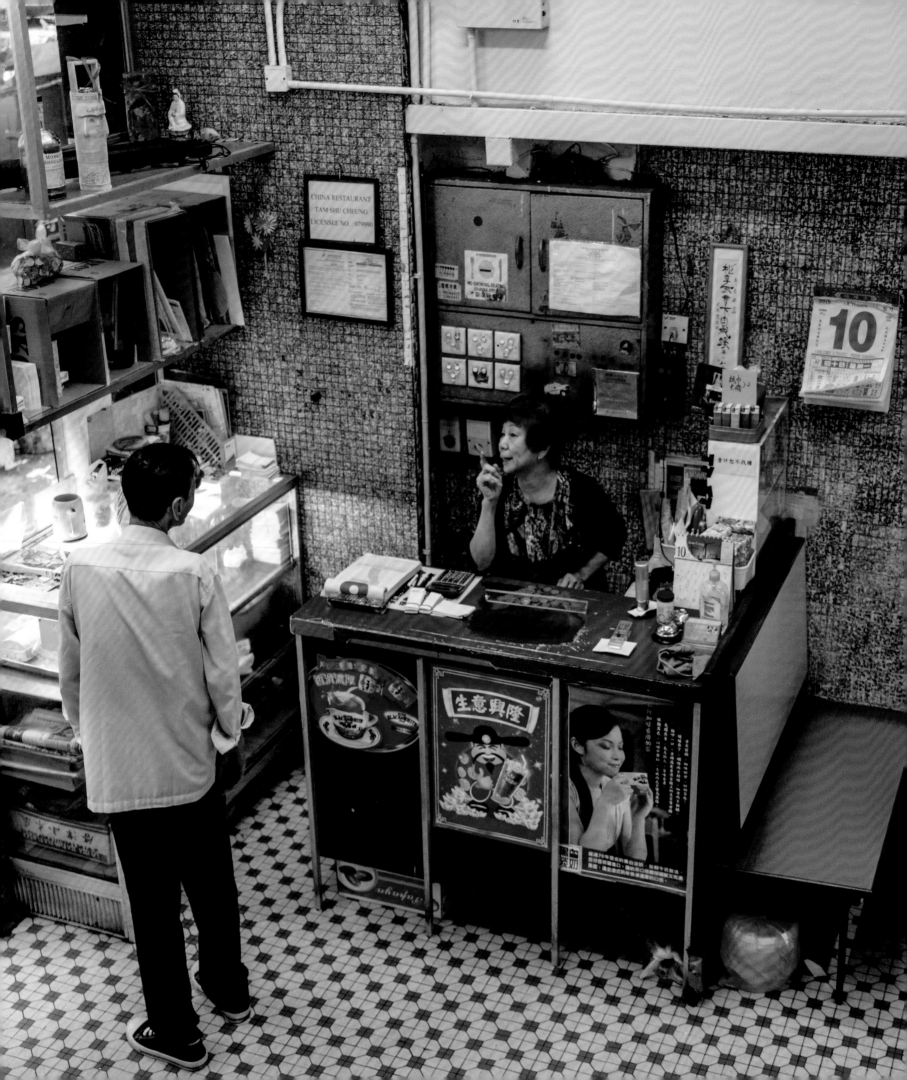

BECKY TAM 譚姨
MANAGER AT CHINA CAFÉ BING SUTT
中國冰室

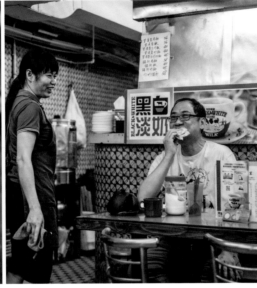
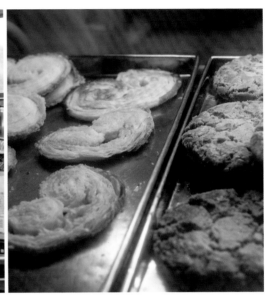

Becky Tam has worked in the China Café for more than 50 years and starts every morning with a hot cup of Hong Kong-style milk tea. As a teenager, she would work part-time at the café for extra money, while her parents worked as servers. Her red-tinted perm and friendly smile are reminiscent of an era when working-class people would flood the bing sutt daily for an afternoon gossip. But today, she says, people demand more variety in the menu and nobody talks to each other like they used to. Modest and shy, Becky epitomises the humble charm of the bing sutt and its dwindling presence on Hong Kong's streets.

"OF COURSE THERE ARE SOME GANGS RUNNING HERE IN MONG KOK. QUITE A LOT OF THEM WILL COME BY TO EAT AND CHAT. I'M NOT SCARED OF THEM. WE ARE ALL PART OF THE MONG KOK FAMILY."

"IN THE PAST, PEOPLE WERE ALWAYS CHATTING HERE, BUT MOST PEOPLE NOWADAYS JUST PREFER TO SIT ALONE AND STARE AT THEIR PHONES."

THE INDUSTRY

The *bing sutt* – literally meaning "ice room" because they were some of the first places to provide air conditioning – was established in the 1940s and is thought to be the precursor to the modern day *cha chaan teng*. They gained notoriety for being a meeting place for gangsters and triads. But even so, they provided a relaxing atmosphere for city dwellers to enjoy "East meets West" dishes, such as the wonderfully calorific Hong Kong-style French toast, milk tea and pineapple bun, which ironically contains no pineapple. But due to rising rent and competition from cha chaan tengs, only a few true bing sutts remain.

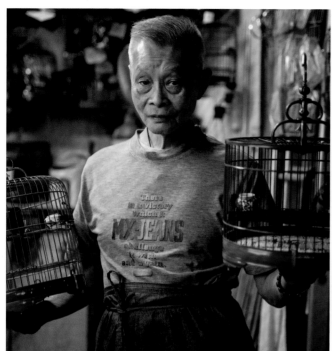
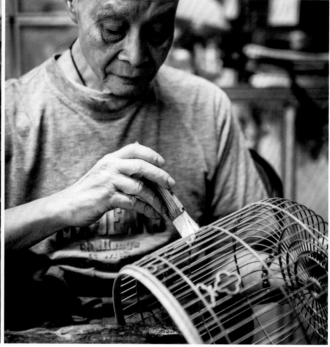

CHAN LOK CHOI 陳樂財
BAMBOO BIRDCAGE MAKER

Hongkongers have always loved their birds. Much like walking a dog, older Chinese men would take their caged birds out in the morning to parks or quiet streets and sit listening to their song. Often you would see the cages hanging from trees, while owners read the newspaper or played mahjong. Birds were typically chosen for their song, instead of their appearance. Nowadays, a handful of these bird-lovers can be found in parks around the city in the early hours, or in Yuen Po Bird Market, but criticism from animal rights groups and the arrival of avian flu in 2012 – with the subsequent bird ban on public transport – have hugely dampened this tradition. Today, the habit of walking a bird has almost entirely disappeared.

"I FIND THE WORK HERE VERY SPECIAL AS YOU CAN'T FIND ANYWHERE LIKE THIS OUTSIDE OF HONG KONG. THIS IS A UNIQUE PLACE THAT REPRESENTS OUR HOME."

"I WOULD LOVE TO HAVE AN APPRENTICE BUT NO-ONE WITH A SCHOOL EDUCATION SEEMS TO BE INTERESTED IN LEARNING THESE HANDICRAFT SKILLS ANY MORE."

THE INDUSTRY
Master Chan Lok Choi has been making cages since he was just 13 years old. His shop in the Yuen Po Street Bird Garden – where a Moon Gate entrance opens to a colourful world of thousands of singing birds, from canaries to Chinese thrushes – is the only one to sell handmade bamboo cages. Master Chan was taught the craft at a young age by his uncle and another famous cage-maker. It involves delicately bending bamboo rods into place, carving patterns or scriptures onto them and painting the cage. Unlike in his younger years, it now takes Mr Chan several months to make a cage from scratch. And now in his 70s, with none of his children keen to learn his trade, he understands his industry is fading quickly.

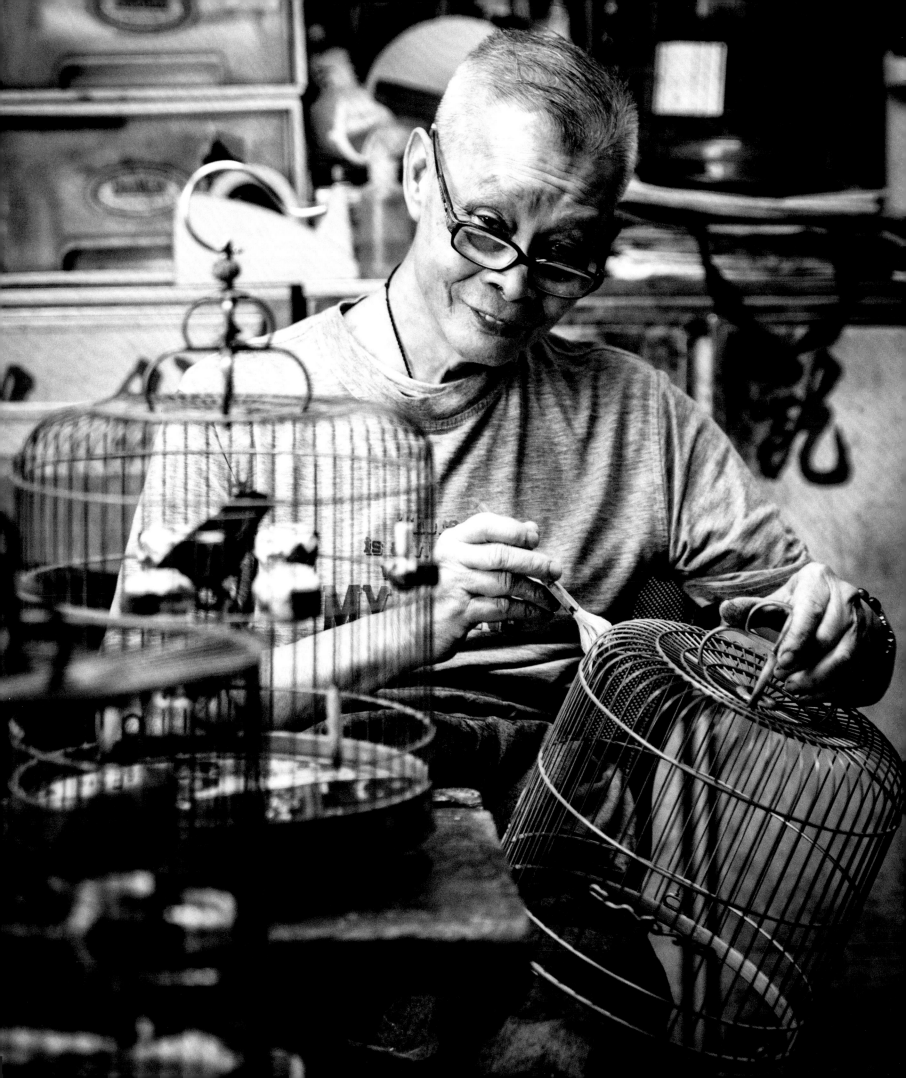

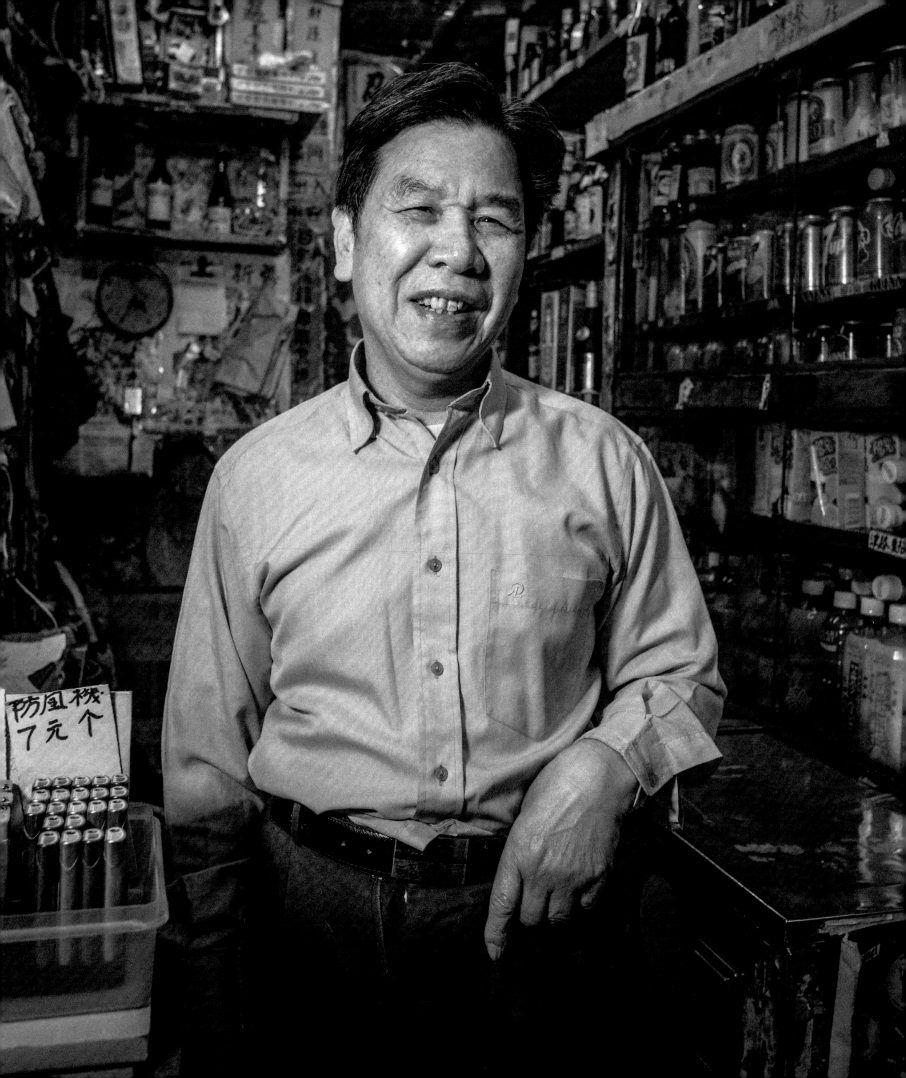

防風機
7元个

MR SHING 阿成
OWNER OF SHING'S CONVENIENCE STORE
成記士多

Mr Shing bought his shop 23 years ago from a friend who could no longer afford to run it. The cupboard-sized store is full of typical Hong Kong treats, such as dried plums and preserved lemon peel, as well as Chinese rice wine, balloons, cigarettes and children's toys. The toys he sells are of the simple plastic variety, which were once very popular in Hong Kong. Originally from the mainland city of Chiu Chow, Mr Shing has lived in Hong Kong for most of his life and works at his Yau Ma Tei shop 13 hours a day to support his family. Like many other independent convenience stores in Hong Kong, he faces stiff competition from chain stores and struggles for space to fit in extra stock. Despite the difficulties, he loves working in Yau Ma Tei because of the people he meets and his friendly neighbours.

"THIS SHOP IS MY WHOLE LIFE. IT HAS RAISED MY TWO SONS AND MY FAMILY. BUT IT HAS ALSO MEANT THAT I HAVE LITTLE TIME TO SPEND WITH THEM BECAUSE I NEED TO BE HERE EVERY DAY. MY SONS SELDOM COME TO HELP, THEY DON'T LIKE WORKING HERE."

"MANY CHILDREN BEG THEIR PARENTS TO BUY MY TOYS FOR THEM! BUT MOST OLDER CHILDREN NOW LIKE IPHONES AND IPADS, I DON'T THINK THEY WANT THESE SIMPLE TOYS AT ALL ANY MORE."

THE INDUSTRY

In 1972, Hong Kong surpassed Japan as the world's largest exporter of plastic toys. By 1980, the city boasted more than 2,000 toy factories, employing some 56,000 people. However, the mainland soon opened its doors to production and by the mid 1980s, 80 per cent of Hong Kong's factories had relocated across the border. Shops that once relied on the sale of toys had to sell other items, such as drinks, snacks or cigarettes. These businesses now face fierce competition from major chains, such as 7-Eleven, which opened in Hong Kong in 1981 and now operates 900 stores across the city.

LUK SHU CHOI & LUK KEUNG CHOI
陸樹才 & 陸強才
OWNERS AND CRAFTSMEN AT BING KEE COPPERWARE
陸炳記銅器

 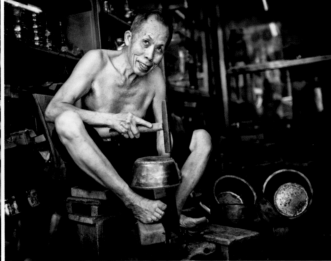 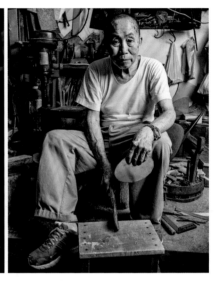

In the 1950s and 1960s, most Hong Kong families used copper kitchenware. With pots, pans and kettles all made out of the durable material, the copperware industry was thriving and there were about 30 shops across the city selling everything from urns to door knockers. However, stainless steel gradually replaced copper as the favourite of families and restaurants, because it was far easier to clean and less reactive to acid. Nowadays, it is mainly traditional Chinese herbal tea shops that use copperware over stainless steel. However, many professional chefs still use copper cookware for its ability to heat quickly and evenly, but very few places in Hong Kong continue to make the products.

"I MADE THE GIANT GONG IN THE HONG KONG RACECOURSE. I LOVE IT AS I SEE IT EVERY YEAR ON TV WHEN THE HORSE RACING SEASON STARTS. I'M VERY PROUD THAT I HAVE LEFT SOMETHING SIGNIFICANT TO SOCIETY."

Luk Shu Choi 陸樹才

"I COOK WITH COPPER UTENSILS. BUT I ALSO LIKE TO USE AN ELECTRONIC RICE COOKER AS IT'S REALLY CONVENIENT. YOU CAN'T JUST STICK WITH THE OLD THINGS; WE ALSO HAVE TO FOLLOW TRENDS AND THE DEVELOPMENT OF THE WORLD."

THE INDUSTRY

Luk Shu Choi and Luk Keung Choi are the sons of the late Luk Bing who established Bing Kee Copperware in the 1940s. For nearly 80 years, the Yau Ma Tei shop has been producing hand-hammered copperware for restaurants, homes, tea shops and hotels. The Luk brothers learned the trade from their father and they still work in the same family shop despite the lack of air conditioning. It takes a full day to finish one pot and each one costs about HK$700. The shop is brimming with handcrafted kitchenware, urns, door knockers and other trinkets. The floor is littered with hundreds of hammers and old tools, which have been acquired over time as other copperware shops have closed down and donated their wares.

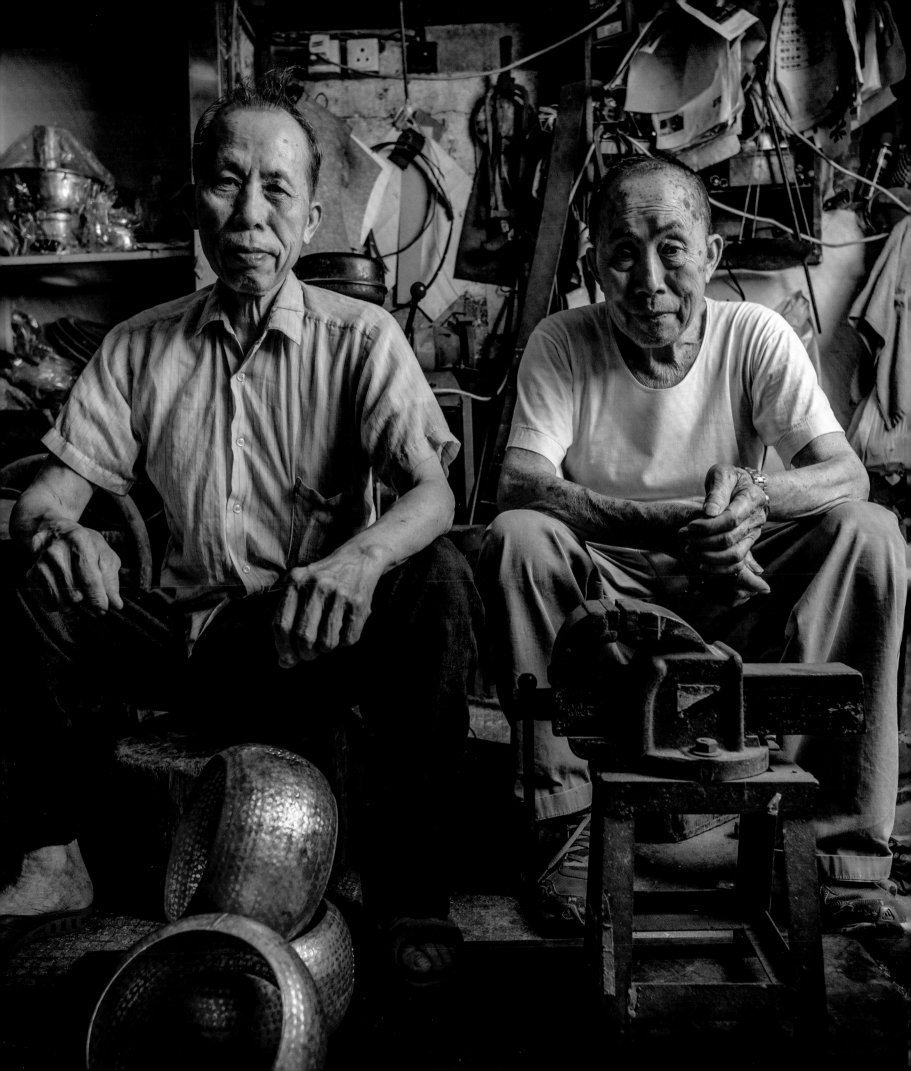

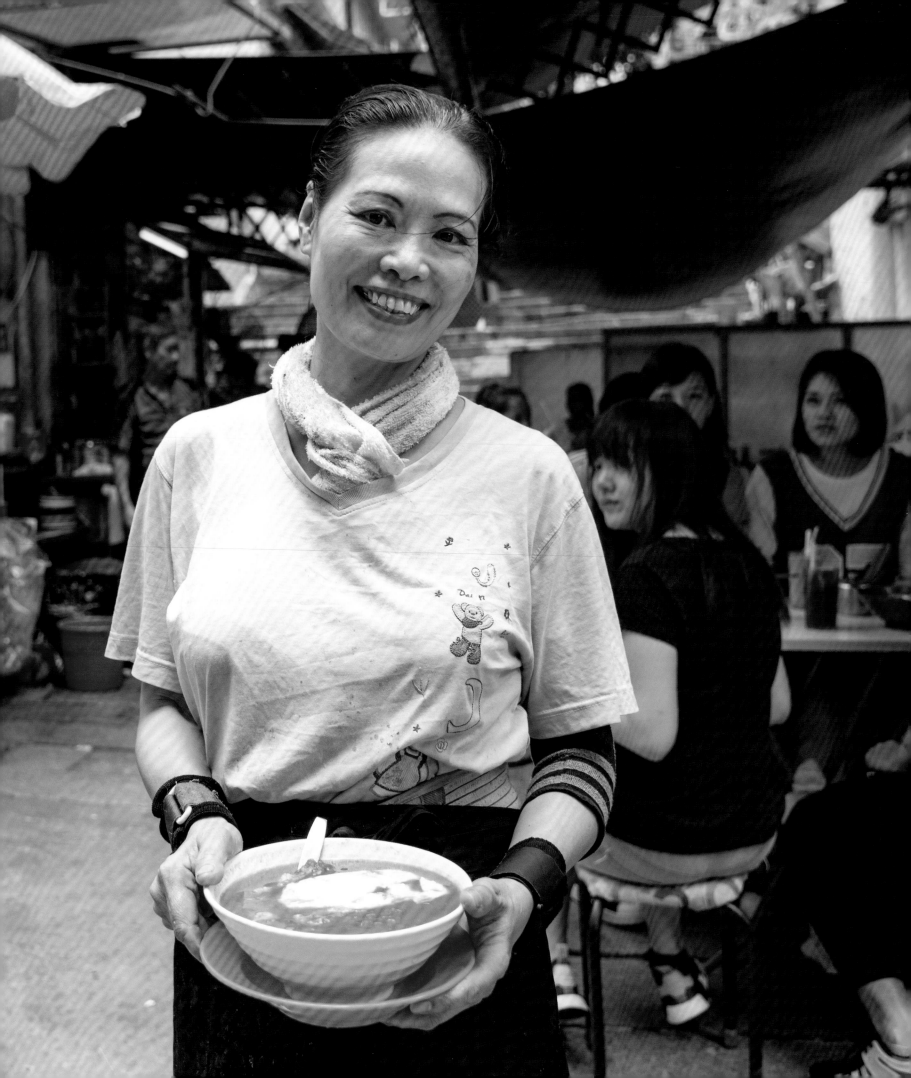

IRENE LEE 李愛蓮
OWNER OF SING HEUNG YUEN DAI PAI DONG
勝香園

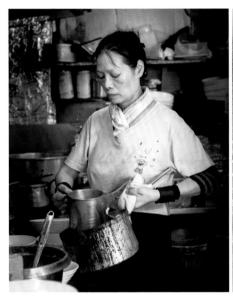
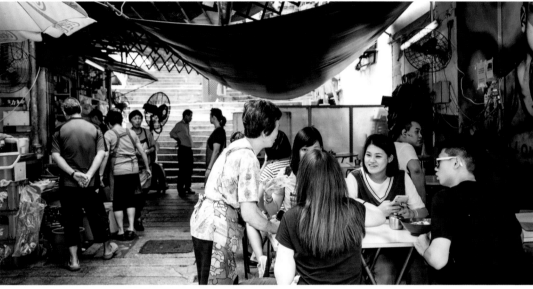

Irene is the owner of Sing Heung Yuen, one of Hong Kong's last and most popular dai pai dongs, nestled in the backstreets of Central. Each day, office workers, students and tourists pack the outdoor seating, feasting on Irene's famous macaroni in tomato broth, among dozens of other favourites. Despite being the owner and boss, Irene works in the kitchen alongside her staff, some of whom have been there for more than 30 years. Her sweat-soaked shirt and dirty apron, paired with her friendly and affectionate character epitomises the humble charm of Hong Kong's iconic dai pai dong. However, her stall will cease to operate with her. Irene inherited the licence for her eatery from her mother and cannot pass it on to her children.

"THERE'S A CUSTOMER WHO COMES HERE A LOT. I'VE KNOWN HIM SINCE HE WAS SMALL, AND NOW HE IS 43 AND MARRIED. HE USED TO COME HERE AFTER SCHOOL, AND NOW HE IS A LAWYER!"

"PEOPLE OFTEN THINK WE ARE RUDE BUT THAT'S JUST THE DAI PAI DONG STYLE!"

THE INDUSTRY

Dai pai dong literally means 'restaurant with a big licence plate' because of the larger licences they operate under. These open-air hawker eateries may be as casual as it gets in the city, but their delicious and cheap local fare keep Hongkongers and tourists coming back. From hot noodle soup to condensed milk on toast and iced lemon tea, they have been a quintessential part of Hong Kong for decades, but the government stopped issuing the licences in 1956 due to hygiene and overcrowding concerns. In the 1980s the government even offered millions of dollars to buy the licences back from vendors. Today, with fewer people choosing to continue their family businesses, the number of dai pai dong has fallen from the thousands to just a few dozen.

MODERN CITY OF ANCIENT TRADITION

After 156 years under British rule and now 21 years since its return to China, Hong Kong has emerged a hybrid of Asian and Western cultures and influences – a signature blend that makes this metropolis so intriguing.

It is a proud, hard-working and fast-paced city, but its people are known to enjoy the simpler things in life, such as early morning tai chi, a rowdy family hot pot session or an all-night mahjong binge.

Treasured custom and feared superstition permeate through many aspects of life: feng shui determines the placement of everything from home furniture to architecture, one always hands over business cards with two hands, and no one would ever stay in hotel room number 444.

For Chinese chop maker Mak Ping Lam, respecting these beliefs is an undeniable part of his work. "When I design the layout of the characters, I must ensure water can flow through them, but never stop or fall out. Water symbolises money so it would be bad if that leaked out," the 68-year-old says.

Hong Kong has a rapidly ageing population, but it is a vibrant city where old meets new on almost every corner. Some 20 per cent of its residents are now aged above 65 years old, but high living costs are increasingly forcing more of them to stay in the workforce – in some cases, well beyond age 85.

Look beyond the city's world famous skyline into the nooks and crannies of the tall buildings and there lies a plethora of ancient crafts and trades largely survived by these older generations. And although they are slowly passing, these tradesmen and women continue to give this metropolis much of its cultural depth.

"BENEATH EVERY GUCCI SUIT OR WHITE LINEN T-SHIRT LIES THE SAME TRUE HONGKONGER; HEARTY, HARD-WORKING AND WITH A TRUE COMMITMENT TO FAMILY"

For example, at the foot of a slick, mirrored Central skyscraper you may find a shoeless man fixing watches or a cobbler examining the heel of an elegant boot, or a food vendor peddling the notorious stinky tofu. All the while, suited businessmen are gathered high above in pristine meeting rooms, discussing financial markets. But as disjointed as they may seem, these two contrasting groups share the same steaming footpaths and the same 2,000-year-old Cantonese language – and it is this meeting of ancient and contemporary that gives Hong Kong its fusion flair.

Although business prevails and "prosperity" is always top of the wishlist during holidays, social class systems are only skin deep. Beneath every Gucci suit or white linen T-shirt lies the same true Hongkonger; hearty, hard-working and with a true commitment to family. Everyone has the same bottle of soy sauce in their kitchen and everyone carries out the same customs on Chinese New Year.

This melting pot of cultures and the boisterous, family-driven character of its people make Hong Kong what it is today; a world class Asian city with a booming economy, intertwined with thousands of traditional customs, cultures and characteristics. Long may its distinctive and irreplaceable identity last.

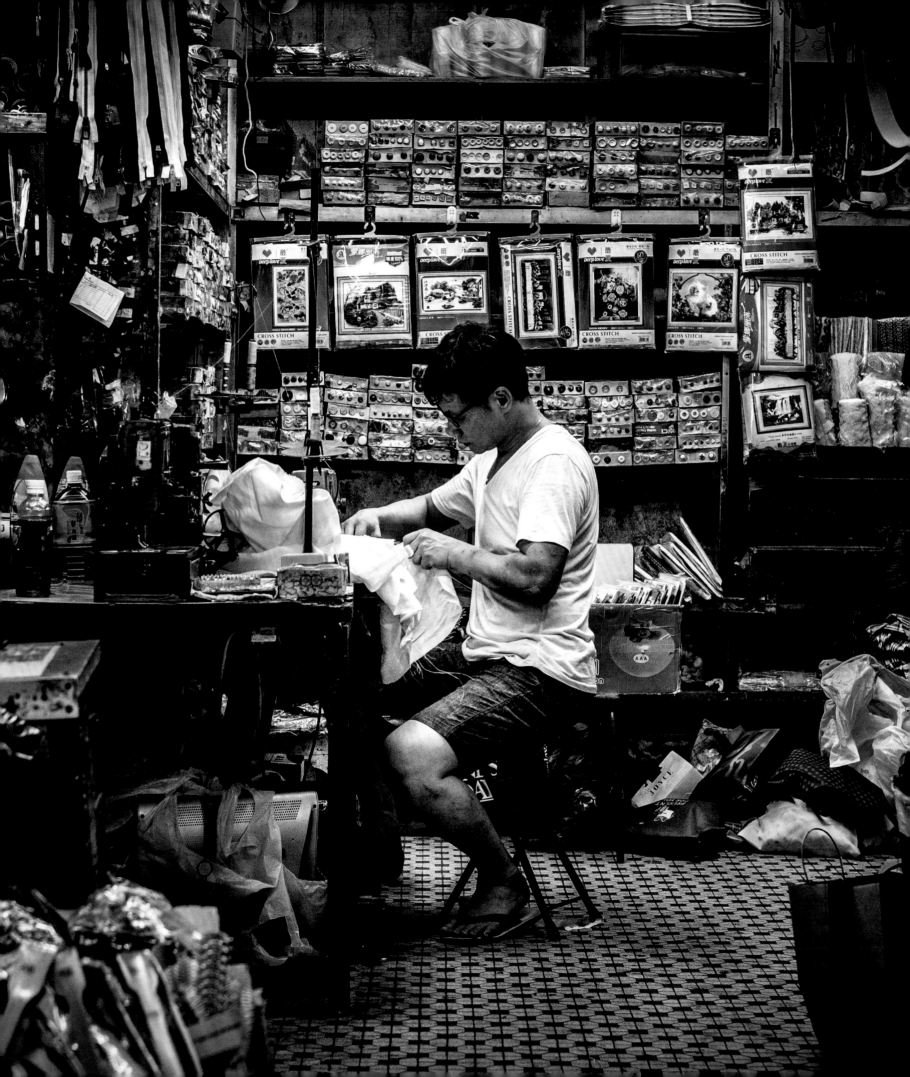

NG KWOK CHEUNG 伍國祥
OWNER OF NG WEI SALTED FISH STALL
伍惠記

Ng Kwok Cheung smiles proudly as he poses at his tiny salted fish stall in Sai Ying Pun. The shrivelled hanging fish sway in the wind, giving off their signature scent. The shop was named after his father Ng Wei, who ran the business when the industry was booming and the street, known as "the salted fish market", was packed with stalls. Today, only Mr Ng's stall remains. Due to a lack of fish in Hong Kong, he says he now sources his produce from countries such as Vietnam, Thailand, Myanmar and Bangladesh. Much of the curing and drying process is now done overseas. He buys the fish from factories overseas and sells them to local restaurants and markets. He says it is not as popular with young people these days. Mr Ng enjoys adding salted fish to his food; his favourite dish is minced pork mixed with dried fish. His expert tip: steam the fish first, then fry it with the pork to bring out the flavour.

"I SUGGEST BUYING THE WHOLE FISH RATHER THAN THE ONE SOAKED IN A JAR OF OIL. YOU CAN'T TELL HOW MANY OR WHAT KIND OF FISH ARE IN THE JAR. SOME BAD MANUFACTURERS EVEN PUT ROTTEN FISH IN AND YOU CAN'T TELL AT ALL!"

"QUITE A NUMBER OF PEOPLE DO NOT LIKE THE SMELL OF SALTED FISH. I THINK IT IS SIMILAR TO DURIAN; THEY FIND THE TASTE TOO STRONG."

THE INDUSTRY

Haam yue or dried salted fish, is a Cantonese delicacy used as a seasoning in Chinese cooking. It could be seen as the anchovy of the East. Originally a poor man's product used to make bland rice dishes more interesting, now it is cherished as a classic. The curing process was invented by fishermen when they were out at sea and had no way to preserve their catch. Half a century ago, Hong Kong's harbourfront from Sheung Wan to Sai Ying Pun was a bustling market, with crowds of locals haggling for the best fish. The industry has shrunk from more than 120 traders in the 1960s and 1970s to fewer than a dozen now. However, the hardy fish merchants that remain continue to run popular auctions once every two months.

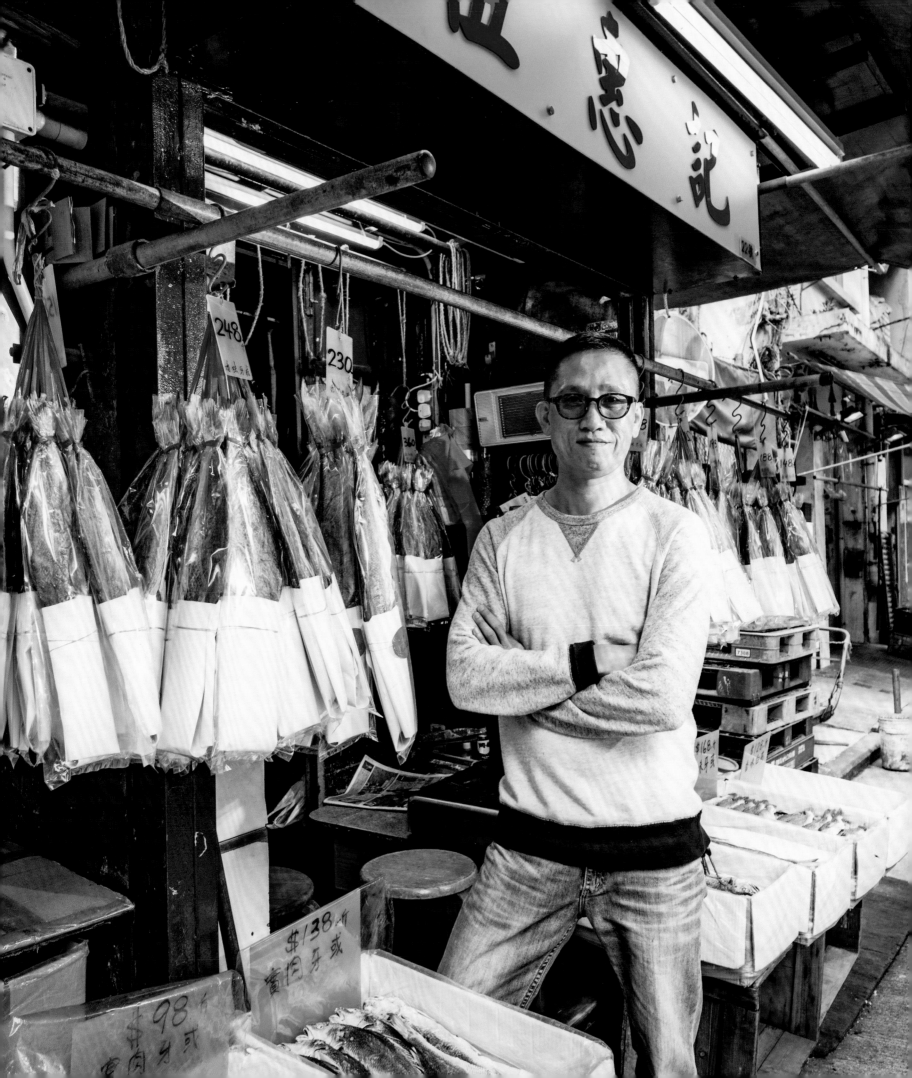

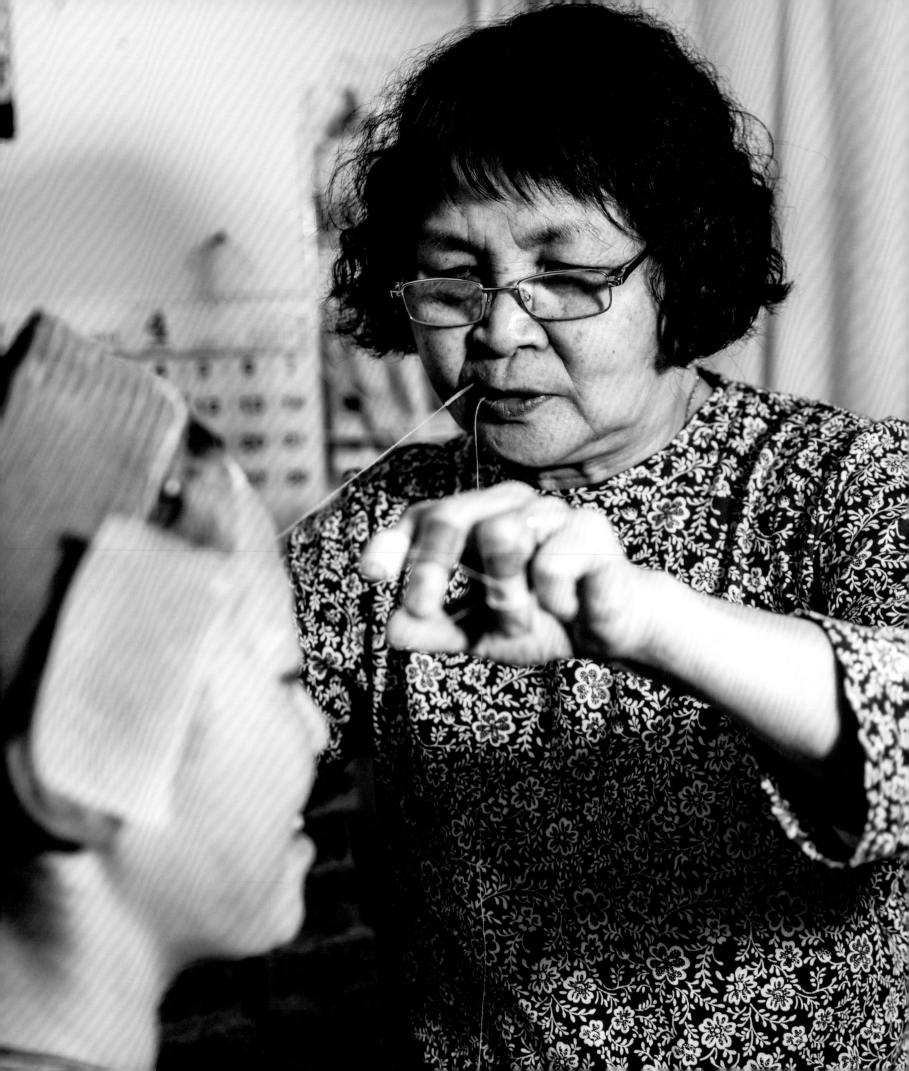

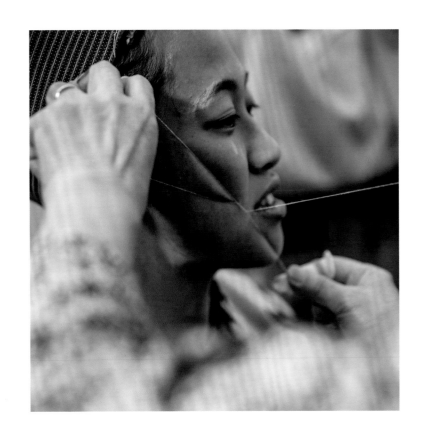

MS LI WAI MUI 李惠妹
FACE THREADER

As a young girl in China, Ms Li watched her mother thread the faces of her customers before she herself started helping during the busy periods, such as Lunar New Year and Mid-Autumn Festival. After she moved to Hong Kong and lost her job in a textiles factory, Ms Li decided to set up her shop. She opens the tiny store at 12pm most days and can see about 20 customers a day. There is often a queue of people waiting outside. Ms Li uses a special technique where she holds one end of the string in her hands and one end between her teeth, as she pulls the hairs out. After many years, she has developed neck pain and her hands are covered in bandages. In recent years, her daughter has helped to promote her business on Facebook, bringing her a much younger clientele than normal.

"I DIDN'T WANT BECOME A FACE THREADER AT FIRST, I ONLY WISHED TO LEARN THE SKILLS SO I COULD HELP MY FAMILY AND FRIENDS. BUT WHEN I MOVED HERE I DIDN'T HAVE ANY OTHER SKILLS."

"A FEW FOREIGNERS CAME BEFORE, I GUESS THEY SAW ME IN A TOURIST GUIDE AND WANTED TO TRY. THREADING IS HARDER IF THEY HAVE A TALL NOSE. AND THEY ARE VERY HAIRY!"

THE INDUSTRY

Face threading goes back thousands of years and is said to have originated either in China or India. It involves covering the face in powder to make the hair more visible and then rolling a twisted piece of cotton or nylon thread across it to remove tiny hairs, dead skin and blackheads. Despite being slightly more painful than the alternatives, if done correctly, threading is a more natural and faster method. Hair grows back thinner and lighter unlike other forms of hair removal. Traditionally, Chinese women had their entire face and neck threaded before their wedding day in order to "open up their face" for the groom. The practice has been largely replaced by tweezing, waxing, shaving or permanent laser hair removal. Today, there are only a few dozen traditional practitioners in Hong Kong.

LO SAI KEUNG 盧世強
OWNER OF SUNRISE PROFESSIONAL PHOTOFINISHING

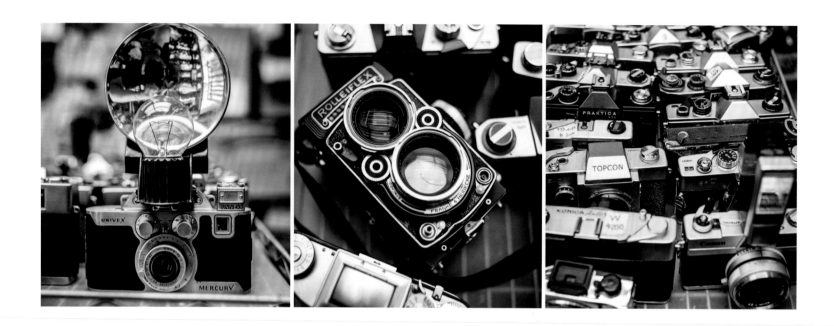

Sunrise Professional Photofinishing is a regular haunt for photography buffs in Hong Kong. The small shop in Sham Shui Po is packed with new and second-hand cameras and lenses. Although the shop has been open since the late 1970s, Mr Lo and his partner took over the business in 2009 and began collecting and selling hundreds of second-hand film cameras, which date as far back as the 1930s. The cameras range from a few hundred dollars to tens of thousands of dollars, depending on the condition and quality. Nowadays, Mr Lo says he develops about 20 to 30 rolls of film a day; however, in the 1970s and 1980s, he would process about 200 a day. Most of Sunrise Professional Photofinishing's customers are young, curious photography students looking to try their hand at analogue photography. But perhaps his favourite regular customer is beloved Hong Kong film star Chow Yun Fat, who is a keen photographer.

"I REALLY LIKE WORKING HERE. MAKING A PROFIT ISN'T MY FIRST PRIORITY. IT HELPS WHEN YOUR INTEREST IS YOUR JOB."

"HONG KONG PEOPLE LOVE SELFIES; YOU CAN STILL DO THEM WITH FILM CAMERAS ALTHOUGH IT'S HARDER AND YOU WOULD PROBABLY NEED A MIRROR."

THE INDUSTRY

The first digital camera was invented in 1975. Since then, the use of film has rapidly declined and by the early 2000s most people had replaced their analogue cameras with digital versions. The days of winding on your camera for every snap and waiting days to develop your pictures are over. In fact, today's youth look no further than their pockets to take pictures – the camera phone is now the most popular form of photography. In the 1990s, there were about 1,000 shops developing film around Hong Kong. Now, there are less than 50. Most shop owners saw the demise of film and quickly adapted to digital cameras, lenses, photo processing or printing; however, a few hardy shops still sell film and analogue camera equipment to passionate enthusiasts.

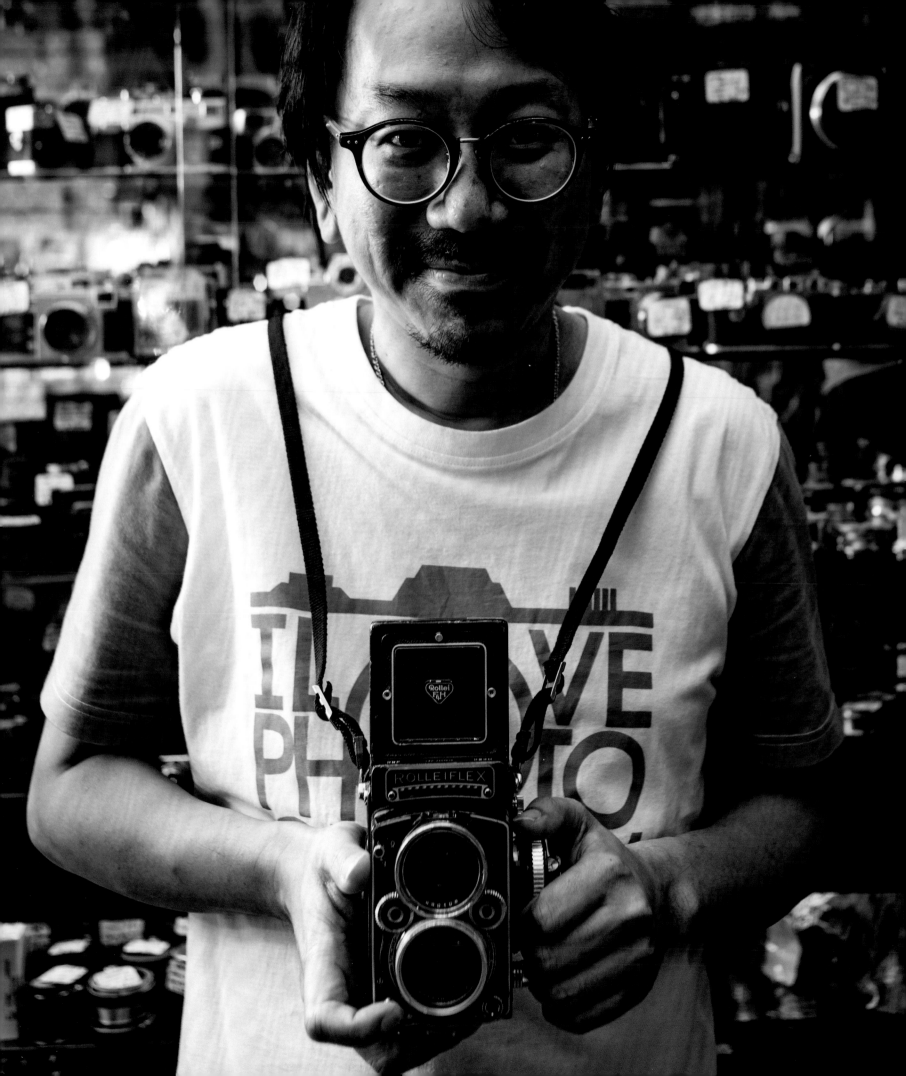

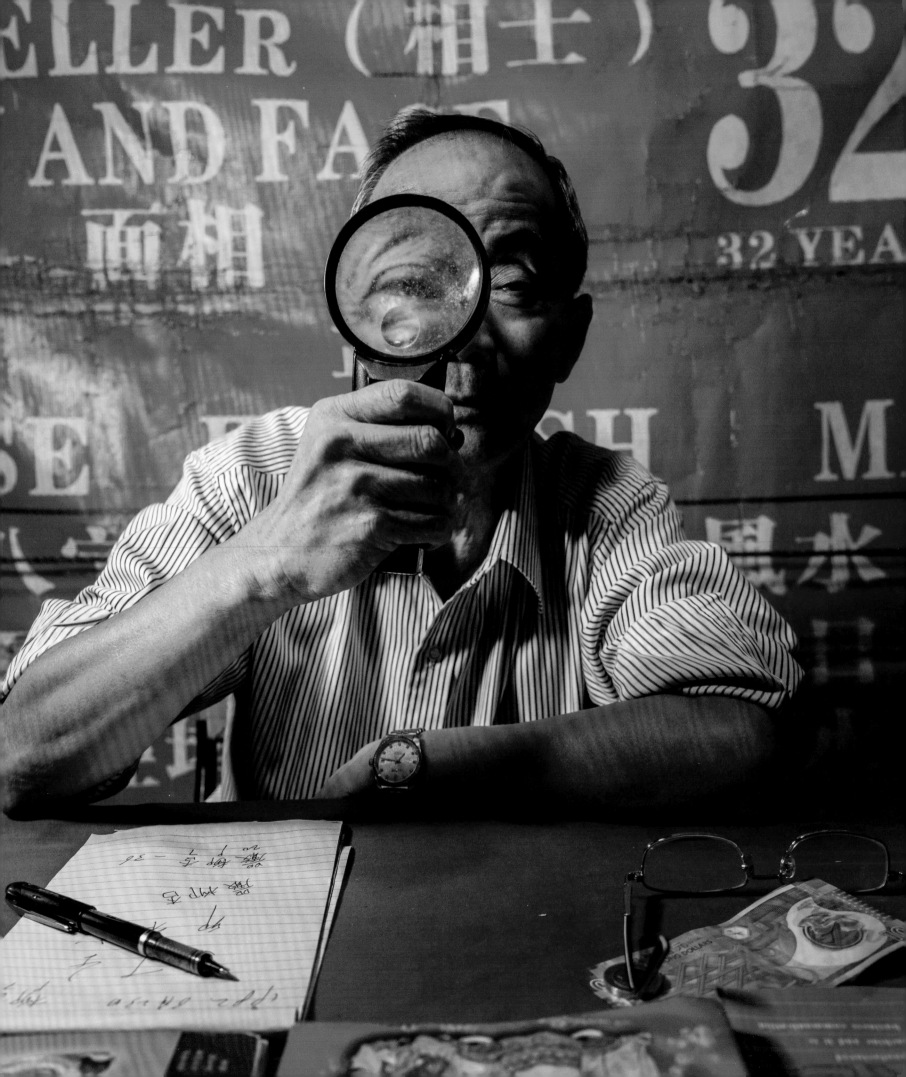

WILLIAM KAM 法誠居士
FORTUNE TELLER

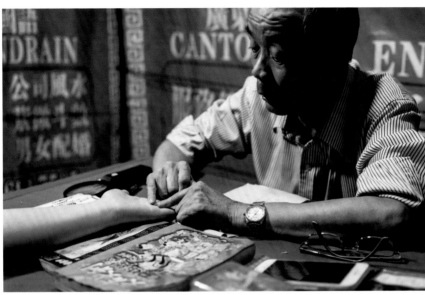 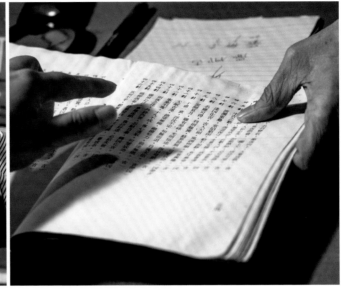

Mr William Kam is a self-proclaimed, 100 per cent accurate face and palm reader. He believes fortune telling is 50 per cent talent and 50 per cent hard work and study. Located at the end of the Temple Street night market, Mr Kam's stall is brightly lit with a red tarpaulin backdrop, which proudly displays his accreditation and 25 years of experience. With a business card, a book on the art of fortune telling and a thick magnifying glass in hand, Mr Kam seems like the real deal. His chirpy and sincere nature brings many of his customers back for annual readings. His endearing habit of breaking into songs by The BeeGees makes him an even more entertaining master of his trade. Despite very few people being interested in learning the art of face and palm reading, Mr Kam remains stoic about the future of his trade. Perhaps he knows something we don't.

"I TELL PEOPLE THE WHOLE TRUTH ACCORDING TO WHAT I SEE, EVEN IF IT'S BAD NEWS. FOR EXAMPLE, WHEN I SEE THAT SOMEONE WILL GET DIVORCED, I WILL STILL TELL THEM. SOME MIGHT EVEN GET DIVORCED MORE THAN ONCE!

"TWENTY-TWO YEARS AGO, MOST OF MY CUSTOMERS WERE LOCALS OR PEOPLE FROM CHINA, BUT NOW THAT THIS STREET IS FAMOUS, I GET PEOPLE FROM ALL OVER THE WORLD. TOURISTS LOVE IT HERE! HOPEFULLY THAT HELPS CONSERVE THIS PLACE."

THE INDUSTRY

Temple Street is best known for its triads, prostitutes, fake designer goods and traditional eateries. But another attraction lies at the end of the night market: the mystical fortune tellers. The market has been a mainstay of the famous street since before the 1920s and soothsayers first set up shop in the 1970s, offering everything from palm and tarot card readings to bird fortune telling, where a small wing-clipped bird pecks out your future from a deck of cards. In the past, customers were mostly locals or visitors from the mainland looking to ascertain whether they would eventually get rich or get married, but nowadays the fortune tellers are a must-see for giddy tourists looking to soak up the culture.

WONG SHUE YAU 黃樹有
LETTERPRESS PRINTER
有恒印務公司

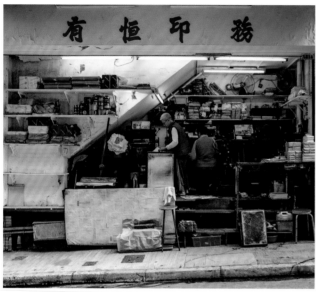 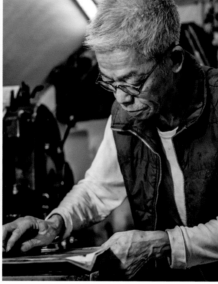

Mr Wong is a strait-laced, wiry man with ink-stained hands who has worked side-by-side with his wife for more than 60 years. They opened their printing shop, which is nestled in the side of a hill in Sheung Wan, 44 years ago. He learned the craft as a young man and eventually saved enough money to buy a second-hand machine. In those days, a state-of-the-art Heidelberg printing press cost the same as a small Hong Kong apartment. In his heyday, Mr Wong produced business cards and letter paper for Reuters and other big firms, but now things are very different. Most of his orders need to be passed on to digital printers and delivered back to clients faster. But when something special does come along, he still fires up his beloved Heidelberg and does it by hand. Mr Wong says when he is forced to retire, he will donate the machine and his thousands of miniature Chinese characters to a museum.

"LESS AND LESS PEOPLE NEED THIS SERVICE NOW. ASK YOURSELF, HOW LONG HAS IT BEEN SINCE YOU WROTE A LETTER OR SENT SOMEONE A REAL CHRISTMAS CARD? AND NOW, PEOPLE LIKE TO USE SMARTPHONES SO WE DON'T HAVE MUCH BUSINESS."

"TO FIND A CERTAIN CHARACTER, THERE IS A PATTERN LIKE IN A DICTIONARY. WHILE IT IS NOT DIFFICULT FOR US TO FIND, IT'S BECOMING HARDER BECAUSE OUR EYESIGHT IS GETTING WORSE."

THE INDUSTRY

Before the digital wave all mass-produced printing was done by letterpress – an arduous technique of relief printing whereby a direct impression of an inked type is stamped. Workers individually select each character, letter, number or design, and arrange them by hand. Compiling Chinese type is especially time consuming because there are some 5,000 characters to sift through. The method was widely used across Hong Kong until the 1980s, with some 200 businesses scattered around Central and Sheung Wan, but today there are only one or two. And with the last Hong Kong manufacturer of type blocks shutting its doors in 1993, the printing businesses' characters slowly wear down and cannot be replaced.

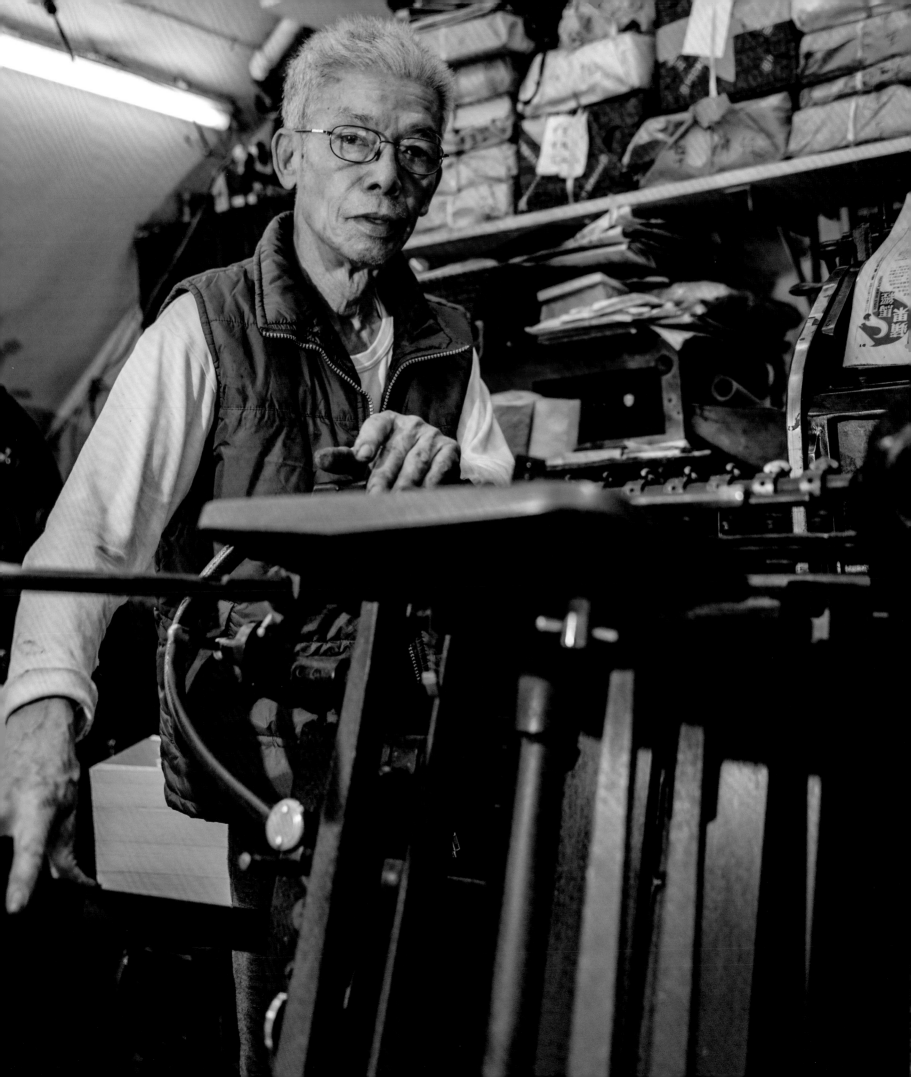

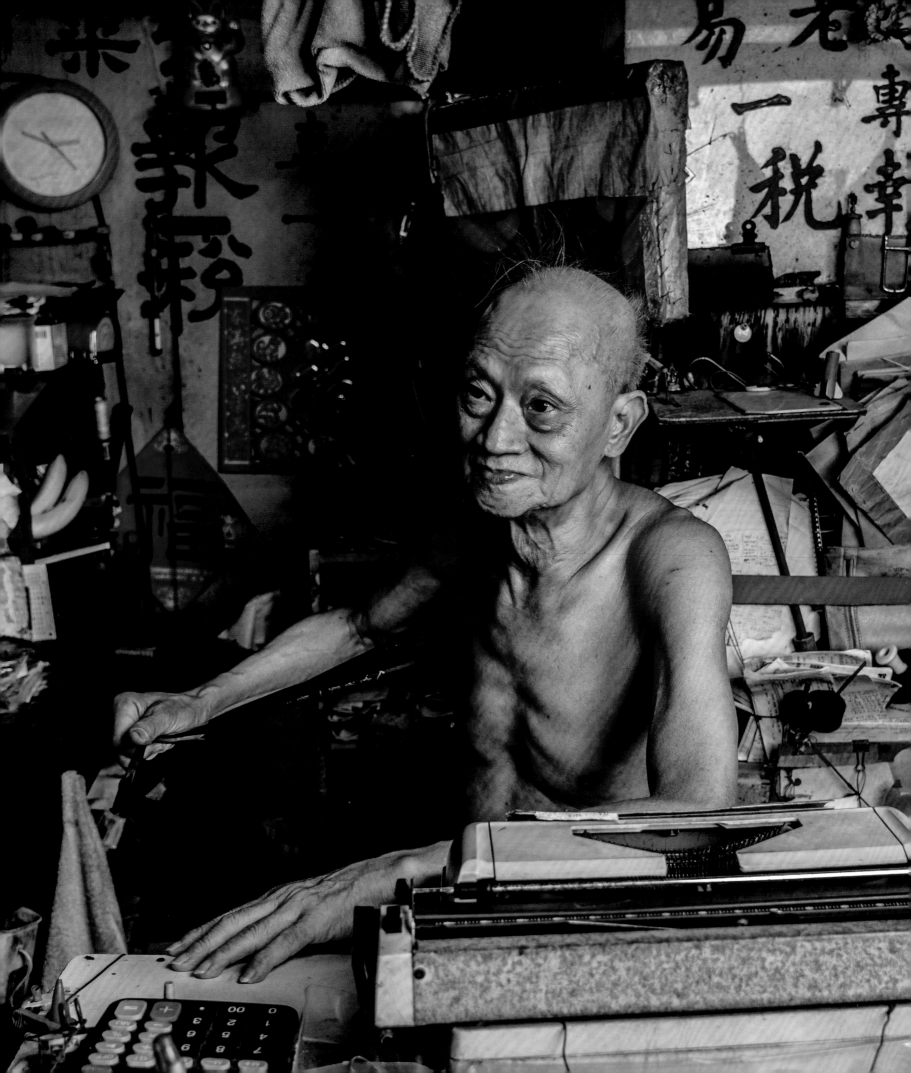

LEUNG LO YIK (CHEN KAU) 梁老易
LETTER WRITER

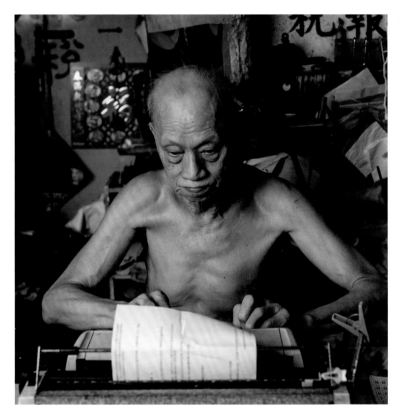

> "THE DEVELOPMENT OF TECHNOLOGY LIKE SMARTPHONES AND COMPUTERS IS THE BIGGEST ENEMY OF OUR INDUSTRY. BUT AT THE SAME TIME IT IS ESSENTIAL FOR A CITY OR ANY SOCIETY TO IMPROVE WITH TIME. THERE MUST BE SOME JOBS THAT ARE REPLACED OR EVEN ELIMINATED. AND I THINK WE ARE ONE OF THEM."

THE INDUSTRY

Letter writing used to be an essential and very profitable business in Hong Kong during the 1950s and 60s when the city's literacy rate was as low as 60 per cent. Letter writers, or *se seun lo*, sat at individual stalls offering their services to all manner of people who wanted to contact relatives on the mainland or overseas, write legal documents, or fill out forms or applications. As well as writing letters, they also had to read letters to illiterate customers. However, since Hong Kong introduced compulsory education in 1971, and with the rapid evolution of modern technology, demand for letter writers has fallen and now there are fewer than 10. Once a common sight on side streets and back alleys, the few remaining letter writers now confine themselves to a small dark corner of the famous Yau Ma Tei Jade Market. The government has long since stopped issuing licences for letter writers.

Chen Kau has been a letter writer for nearly 40 years. Originally from Vietnam, where he worked as an accountant for a film production company, he first came to Hong Kong in 1972 and took a job as a bartender. Given his education and proficiency in English, a customer suggested he become a letter writer. Soon he was helping people write letters to their families overseas and assisting in legal matters. His most memorable job was helping a desperate woman, whose husband had long since abandoned her, to write an announcement in the newspaper to assist in her divorce proceedings. Today, Chen sits shirtless and sweaty in the market, using the same typewriter he has always used. In fact, he says he has never used a computer and has no intention to switch. Nowadays, only a handful of regular customers come to him for help with tax forms, welfare applications or visas. And most days, he has no customers at all, so he spends his time reading the newspaper or chatting.

> "I THINK MY JOB REPRESENTS THE PEOPLE FROM THE LOWER SOCIAL CLASS IN HONG KONG. AND WE REPRESENT A DIFFERENT HONG KONG, FROM THE BRITISH COLONIAL PERIOD."

WHY ARE THESE INDUSTRIES DISAPPEARING?

Hong Kong's cultural identity was once characterised by thousands of open-air stalls selling delicious local snacks, tradesmen touting their handcrafted wares, and Chinese tradition and religious belief presiding over science and Western values.

But fast forward half a century and the city's charm has been diluted by chain stores, generic shopping malls and fast food. People no longer want to eat lunch served by an outdoor vendor; coffee is now something you order "to-go" in a franchised café; if you fall sick, you buy Western medicine; and few people go to a streetside tailor if they tear their shirt pocket. Many of the shops and industries that once embodied Hong Kong's traditional values have been lost forever.

The gradual demise of these industries can be traced back to a handful of factors, such as rising rents, better access to education, technological advances, changes in cultural belief and the onset of big business.

Hong Kong tops lists every year for being one of the most expensive cities to live in, rent and property prices consistently outpace salary increases, and it is often labelled the most competitive economy in the world. In fact, these daunting facts are leading many to abandon the city they grew up in, let alone pursue such volatile career paths in industries that are fast disappearing.

THE RENT TRAP

Hong Kong's notoriously high rent prices are a problem for everyone. But for small, family-run businesses, it can mean being forced to move or shut up shop entirely. For big businesses and chain stores, such high rents mean they can muscle out the smaller players by simply affording the pricey properties. And while these developments have been fantastic for Hong Kong's economy, services have become standardised. So rather than having an eclectic mix of local businesses, many street corners nowadays are populated with the same stores.

"MANY OF THE SHOPS AND INDUSTRIES THAT ONCE EMBODIED HONG KONG'S TRADITIONAL VALUES HAVE BEEN LOST FOREVER."

EDUCATED AND ASPIRING

In the 1950s, Hong Kong's literacy rate was very poor. Only about 65 per cent of the population could read and write, according to the UN, with just a handful of educated elite claiming higher paid jobs. But when the Hong Kong government introduced compulsory education in the 1970s, the city's youth were suddenly given access to schooling. Literacy rates soared and job opportunities opened up. With a better education under their belt, fewer opted to pursue low income professions such as manual labour or traditional crafts. Instead, they looked to the technology industry or had their hearts set on becoming doctors, lawyers or business professionals.

TECHNOLOGY AND AUTOMATION

Advances in technology and automation have played a huge part in the decline of Hong Kong's traditional industries. In the past few decades, rapid developments have led many manual jobs to become obsolete. The simple introduction of cash boxes on public transport and the dawn of the Octopus card era meant that the city's bus and tram conductors were no longer needed. While big factories and machines replaced individual craftsmen, the internet and online services replaced many shops and businesses, and inventions such as the digital camera rendered the entire film industry redundant.

Since the 1980s, with all these factors giving customers fewer reasons to visit their once-regular local vendors, a multitude of shops have shut their doors, making way for a new tide of globalisation. And while the Hong Kong government has pledged to help preserve some of the city's traditional industries through greater exposure and education, the struggle to survive only seems to intensify.

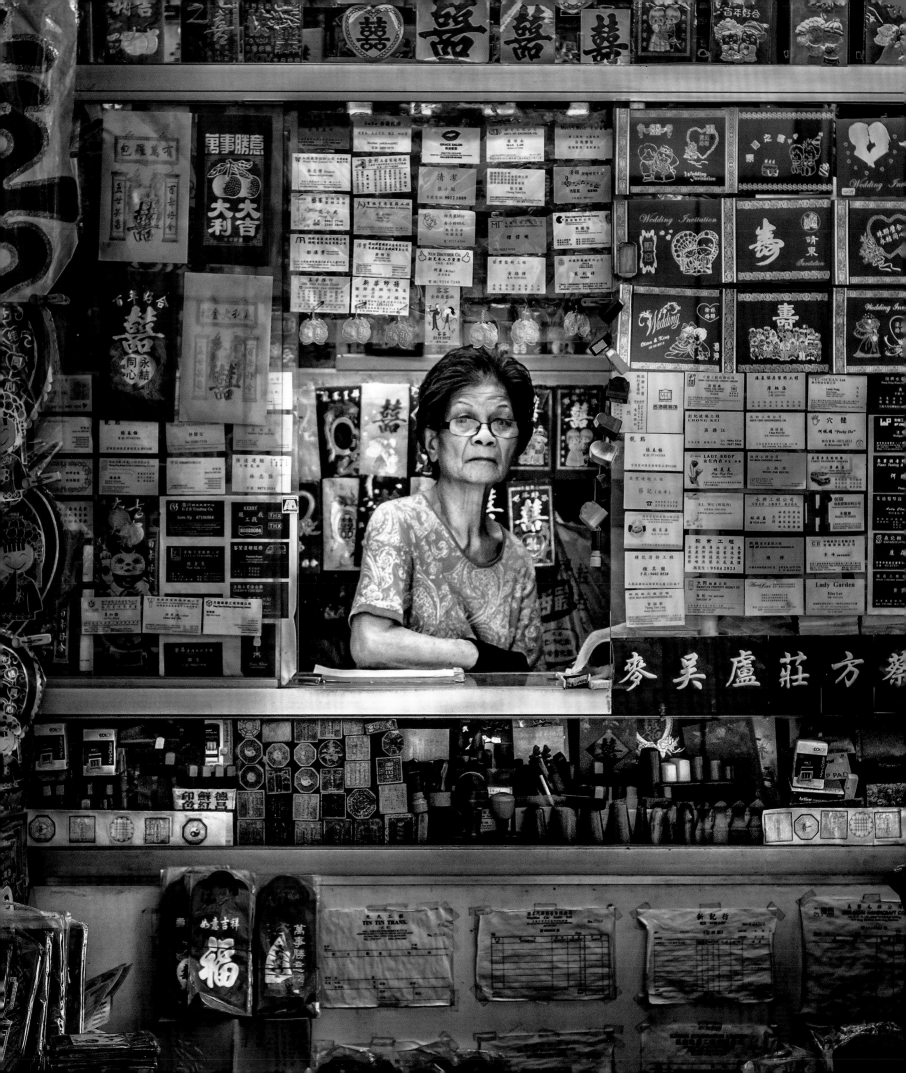

YUEN YUE LAM 源汝霖
OWNER OF YUEN KUT LAM LITTLE BOX OF TEA
源吉林

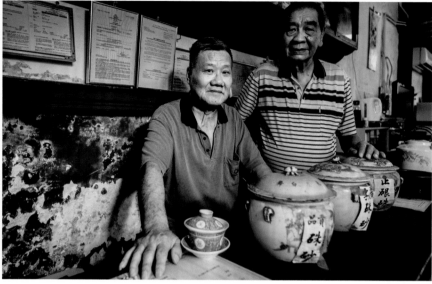

Yuen Yue Lam is the proud sixth generation owner of his family's business, which has been selling medicinal tea for more than 200 years. Originally from China, his family moved to Hong Kong in 1906 and set up shop in Sheung Wan, and soon their brand of tea became a household name. Their factory in Sai Kung uses only Hong Kong-made products, the packaging is the exact same as it was in 1954, and it can be found in supermarkets and Chinatowns around the world. But despite its far-reaching availability, some customers – fearing being sold counterfeits – still travel long distances to buy direct from his shop. But like many in Hong Kong's traditional industries, Yuen Kut Lam faces a quickly ageing workforce and without any apprentices, the business needs to modernise and find new products. Rising rents and competition from Western medicine only add to the struggle. With his modern outlook and three children studying in the UK, Yuen is confident his family business will survive the transition and live to see another generation of tea-makers.

"IN THE PAST, OUR BRAND WAS REALLY FAMOUS. HOWEVER, FEWER PEOPLE KNOW ABOUT US NOWADAYS. A LOT OF PEOPLE PREFER TO SEE WESTERN DOCTORS WHEN THEY ARE SICK NOW."

"WE SUGGEST TAKING A HOT BATH AFTER DRINKING THE TEA AND THEN GOING TO BED. YOU WILL FEEL MUCH BETTER AFTER SWEATING IT ALL OUT WHEN ASLEEP."

THE INDUSTRY

Until the 1970s, most Hong Kong households would have kept *hap zai cha*, or 'little boxes of tea' at the ready for any family member that was unwell or who had a dry throat. The medicinal tea is made from 28 herbal ingredients and is said to fight off illnesses such as flu, stomach or digestive issues. The recipe for the traditional Chinese medicine has remained unchanged for centuries and continues to be used around the world. Making it is a week-long process called "The nine soaks and nine dries". Ingredients are cooked, the juice is extracted, the tea is soaked in the juice and then dried in the sun. This process is repeated nine times and the end result is very bitter with a strong herbal smell. There are no side effects to the tea – like there can be with some Western medicine – but as Hongkongers become more Western in their mindsets, Paracetamol is becoming a more common remedy.

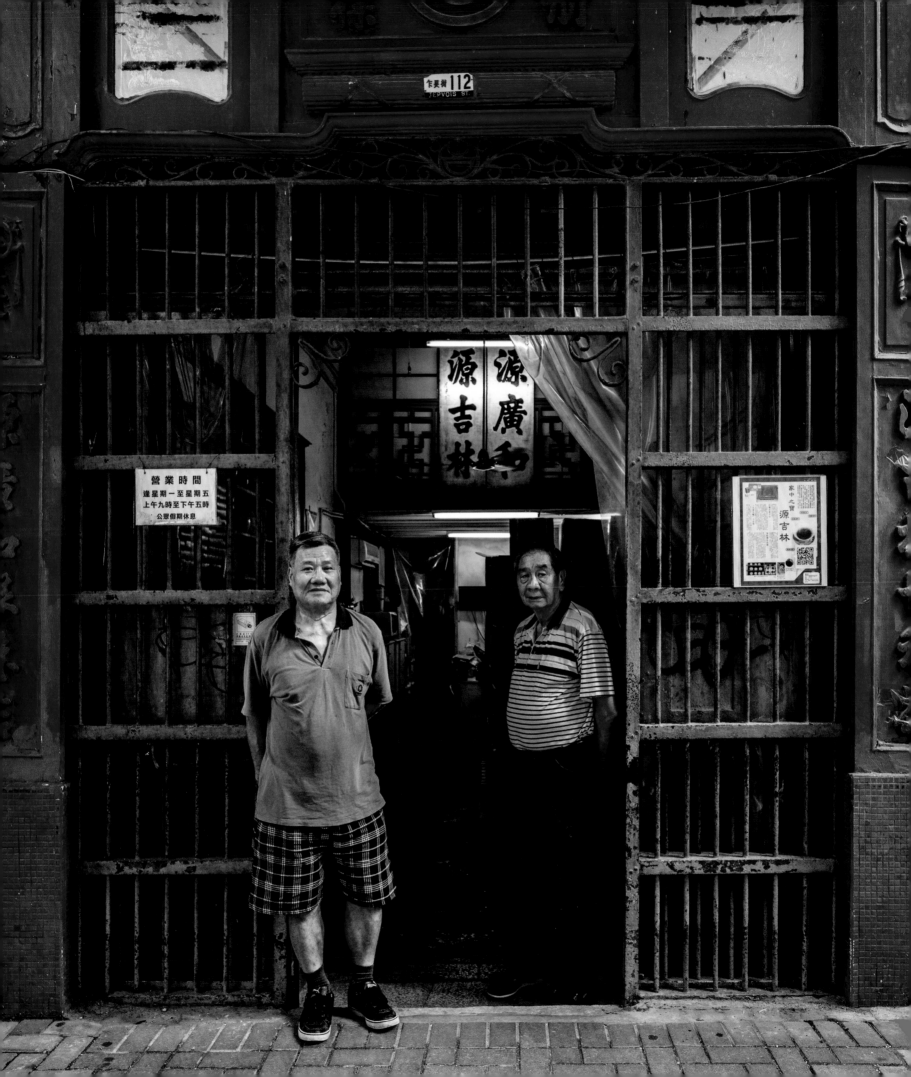

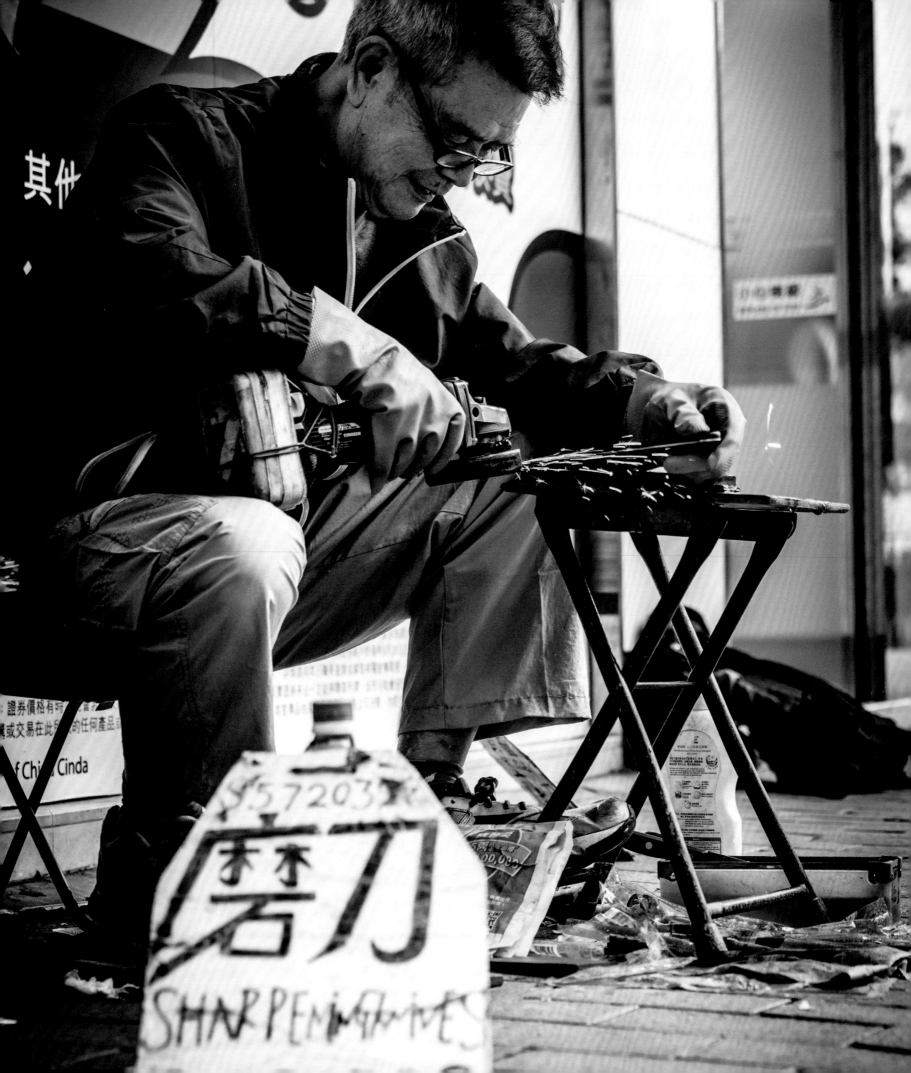

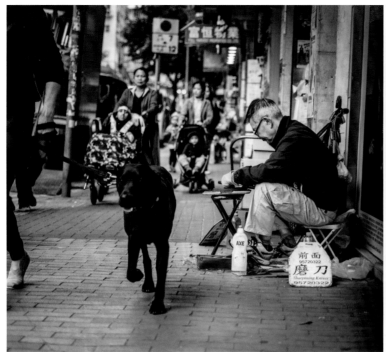

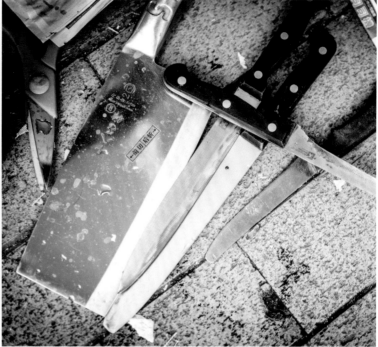

MR LEE 李先生
KNIFE SHARPENER

Mr Lee runs his knife sharpening business on the side of a street in Happy Valley. He picked up his sharpening skills from his previous job in a steel factory. With his wife and children all working, he was left to the household chores, but soon realised he did not like staying home and decided to sharpen knives to bring in some extra cash. He sets up his stall about four or five times a month when he has accumulated a few orders. Most of his work involves sharpening cleavers for market workers, or scissors for fabric workers and tailors. He charges about HK$30 per knife depending on the size and quality of the blade. All Mr Lee needs for his business is a few different stones and his electric blade sharpener, along with a few old bottles which he fills with water and oil. Despite the occasional dull day where business is slow, he enjoys being outdoors and chatting to people who walk by.

"MY WIFE AND SONS ARE STILL WORKING SO I FEEL LIKE I AM THE MOST USELESS IN THE FAMILY. I COOK FOR THEM EVERY DAY AND IN MY SPARE TIME I COME HERE."

"I FEEL BORED IF I STAY HOME ALL DAY. WHEN I WORK HERE, I CAN CHAT WITH PEOPLE AND MEET MORE FRIENDS."

THE INDUSTRY

Before the age of home sharpening kits and the dawn of today's throwaway culture, the only way to keep your blades sharp in Hong Kong was to wait for the weekly cry of the knife sharpener – *yau mo yun mor dou?* (Does anyone need their knives sharpened?). Residents would then gather up their knives and take them to be sharpened on a whet stone by the knife master. In the days when all meals were made at home, the industry was a profitable and much needed one. However, it soon slipped into decline as households cooked less and old knives became cheaper to replace. Despite these changes, there are still several knife sharpening masters, usually operating out of tiny stalls or simply on the side of the street.

CHEUNG SHUN KING 張順景
OWNER AND TILE MAKER AT BIU KEE MAHJONG
標記蔴雀

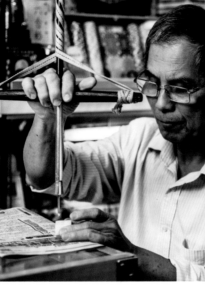
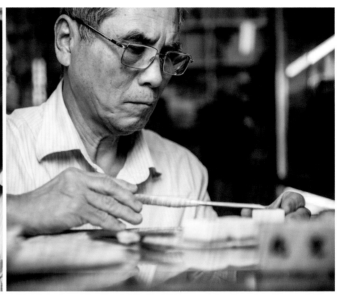

Mr Cheung has been making and selling mahjong tiles for more than 40 years. He learned the trade from his father and grandfather in the family shop, where his first job was painting the tiles. But ironically, between work and his personal life, he has never learned the game. And to be frank, he says he would rather not. Mr Cheung mostly replaces lost or damaged tiles and sells machine-made sets from the mainland for about HK$600. But occasionally he makes a set from scratch, which he personally engraves and paints. These sets cost about HK$4,000 and take months to complete. His hours are long and he only takes one day off every year, but his smile and chirpy nature keep his business afloat. However, reflecting on his life and the ever-shrinking number of tile-making shops, he admits his business will retire with him. He does not want his children to take up the trade because there is simply not enough work, and says the rise of machine-made tiles will spell the end of the craft within a decade.

"I WOULD RATHER REST THAN LEARN HOW TO PLAY MAHJONG. BUT MY CHILDREN LOVE TO PLAY! ALSO, I FEEL BORED JUST LOOKING AT THE MAHJONG TILES AS I LOOK AT THEM ALL DAY EVERY DAY AT WORK."

"WE CAN'T DO ANYTHING TO HELP THE INDUSTRY AS MECHANIC PRODUCTION IS REPLACING US. I FORESEE THAT ALL MAHJONG SHOPS IN HONG KONG WILL DISAPPEAR IN 10 YEARS."

THE INDUSTRY

Mahjong is considered a Chinese art form and has evolved to become the most popular game in Hong Kong, and many other Asian countries. For hundreds of years the four-player game of skill and strategy has brought people together. It involves drawing and discarding tiles, each with a different character on it, to form winning hands. But with such popularity has come industry automation. Mahjong societies, schools and parlours – many of which allow players to gamble – no longer use handmade tiles for their self-shuffling tables. Instead they require factory-made magnetised ones. Consequently, handmade tiles are scarcely seen in Hong Kong and there are very few shops remaining that make them.

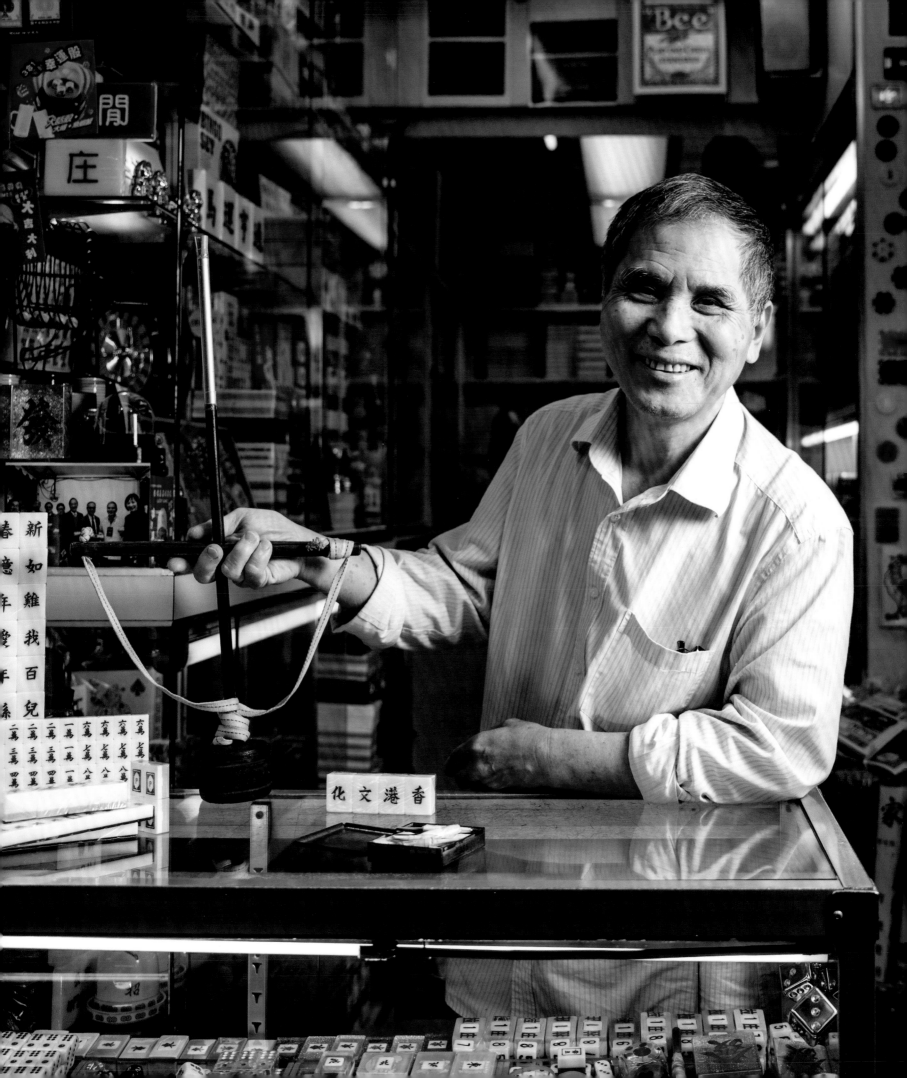

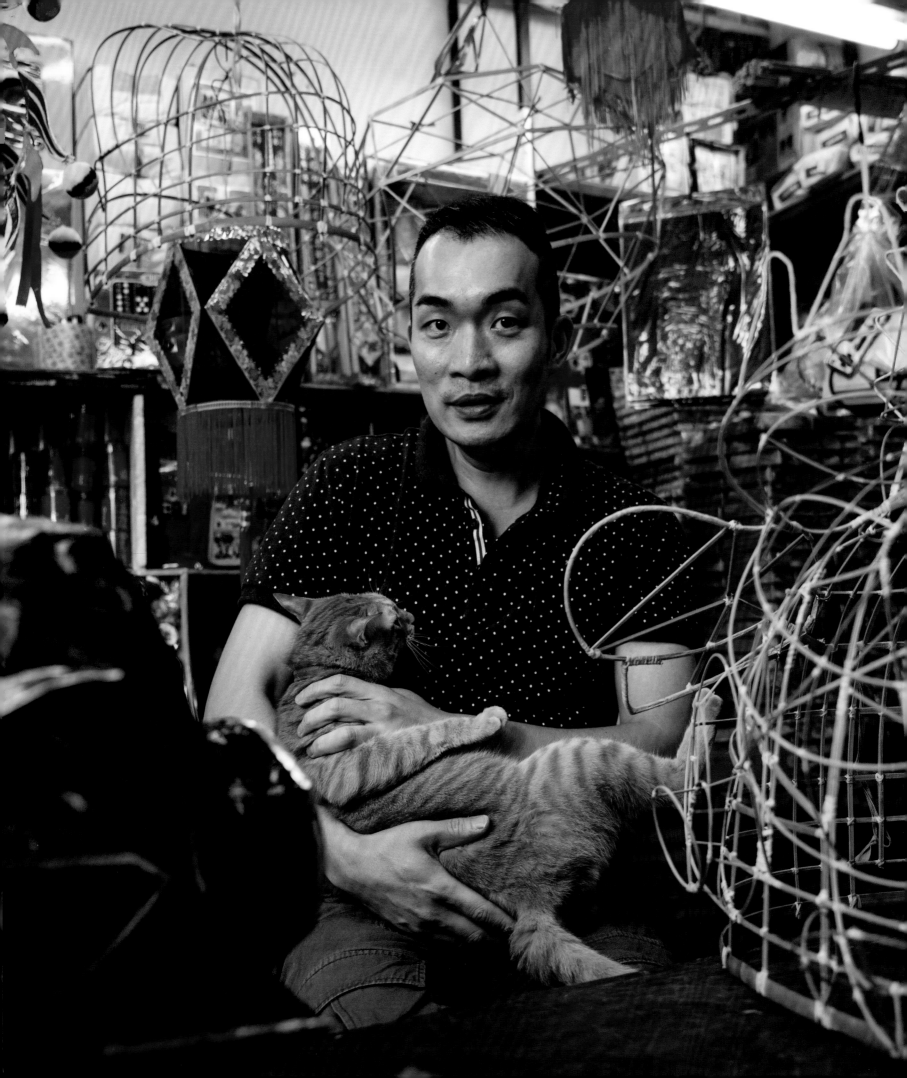

AU-YEUNG PING-CHI 歐陽秉志
PRINCIPAL PAPER EFFIGY ARTIST AT BO WAH EFFIGIES
寶華紮作

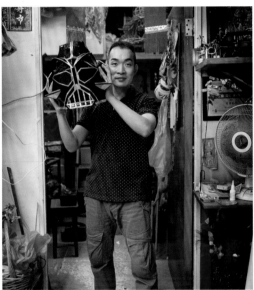

This Nintendo Gameboy replica (left) costs around HK$2,000

Mr Au-yeung Ping-chi has followed in his father's footsteps and been in the business of making paper effigies for more than two decades. Over the years, he has seen people's requests change from life's simpler pleasures, such as a pair of shoes, to more modern-day items, like a Nintendo Gameboy. For 10 hours every day, he hand-makes some of the most detailed and often bizarre paper effigies in Hong Kong. From food, clothes or houses, to a full-sized massage chair, a *wing chun* wooden dummy for a *feng shui* master and even a guitar for the late rock star Koma Wong Ka-Kui of the band Beyond. Mr Au-yeung also teaches the art at community centres and primary schools around Hong Kong in an attempt to keep the tradition alive.

"WHEN I DIE, I WOULD LIKE SOME CARS, HOUSES AND A HI-FI SYSTEM. OF COURSE I WANT THEM HANDMADE TOO, AS THEY ARE BIGGER, MORE GRAND AND BEAUTIFUL. A SUPER DELUXE SEVEN-FOOT-LONG MERCEDES-BENZ AND PORSCHE WILL DO."

"PEOPLE IN THE PAST WERE SIMPLER – THEY DIDN'T NEED MUCH EVEN WHEN THEY WERE ALIVE."

THE INDUSTRY
Burning paper effigies, or *zi zaat*, is a common religious practice in China. They are set alight as an offering to the deceased, particularly around Ching Ming – Hong Kong's annual grave-sweeping festival. Artists carefully bend thin strips of bamboo into elaborate shapes – houses, smartphones or even mahjong tables – coat them with joss paper and paint. Each piece can take weeks to complete and can cost several thousand dollars. The modern era has brought multiple requests for more material items such as laptops, luxury cars and game consoles. Sadly, since factories in mainland China started mass-producing the effigies, many specialised Hong Kong shops and local artists have gone out of business.

LAI WING HONG 黎永康
OWNER OF TAI YIK PAWNSHOP
大益大押

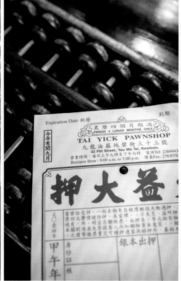
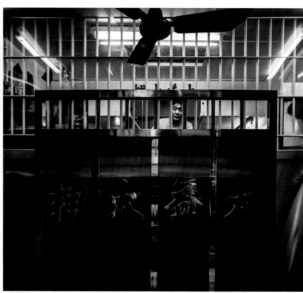

Mr Lai's family have been in the pawn industry since the 1950s. He took over the business from his father, who took over from his father. Now after nearly 40 years, Mr Lai knows the job like the back of his hand and can spot counterfeit items, such as a fake Rolex, almost immediately. But it was not always so easy, it took him about 10 years to develop his expert eye. Wearing a loose sweater, jeans and flip-flops, he clearly has a casual and confident approach to his work, while an amber bracelet around his wrist hints at his traditional values. He works long hours and insists on keeping handwritten records and labelling and wrapping every item before locking them away. Mr Lai's two children, whom he raised in the store's back room where he would lay out beds at night, will not be forced to continue the business, he says. Nevertheless, they have helped in recent years by teaching him how to use the shop's first computer.

"IN THE PAST, IT WAS SAID THAT CHILDREN OF BOAT PEOPLE WOULD NOT GROW UP HEALTHY, SO THEY WOULD REGULARLY PAWN THEIR CHILDREN AND TAKE THEM BACK AFTER A SHORT WHILE TO SYMBOLISE THAT THEY WERE NO LONGER BOAT PEOPLE BUT CHILDREN OF THE PAWNBROKER."

"SOMETIMES YOUNG PEOPLE COME TO SECRETLY PAWN THEIR PARENTS' THINGS FOR MONEY THEY NEED FOR CREDIT CARD OR GAMBLING DEBTS. ONE TIME, A BOY ASKED FOR HIS ITEM BACK LONG AFTER IT HAD EXPIRED AND WE HAD MELTED THE GOLD FOR MONEY. HE BEGGED AND CRIED IN MY SHOP BUT I HAD NO WAY TO HELP HIM."

THE INDUSTRY

The pawn industry is one of the oldest in Hong Kong, dating back to the early 1900s. There are currently about 200 pawn shops in the city, providing residents with quick cash in exchange for gold, diamonds, luxury-brand watches or jewellery. An authentic Rolex can fetch thousands of dollars. Iconic features of these shops include the *dong zung*, a large wooden screen door, which hides customers' identities, saving face in the process. Each morning, police deliver a list of stolen goods to local pawnshops and owners are required to check that none of their goods are on the list.

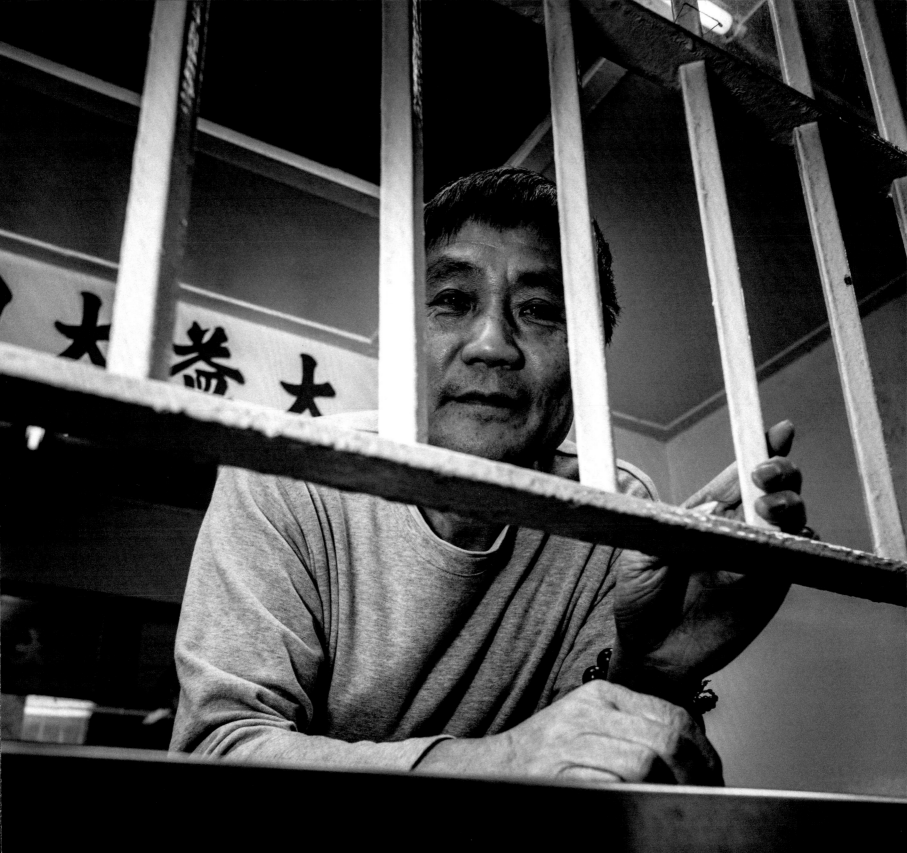

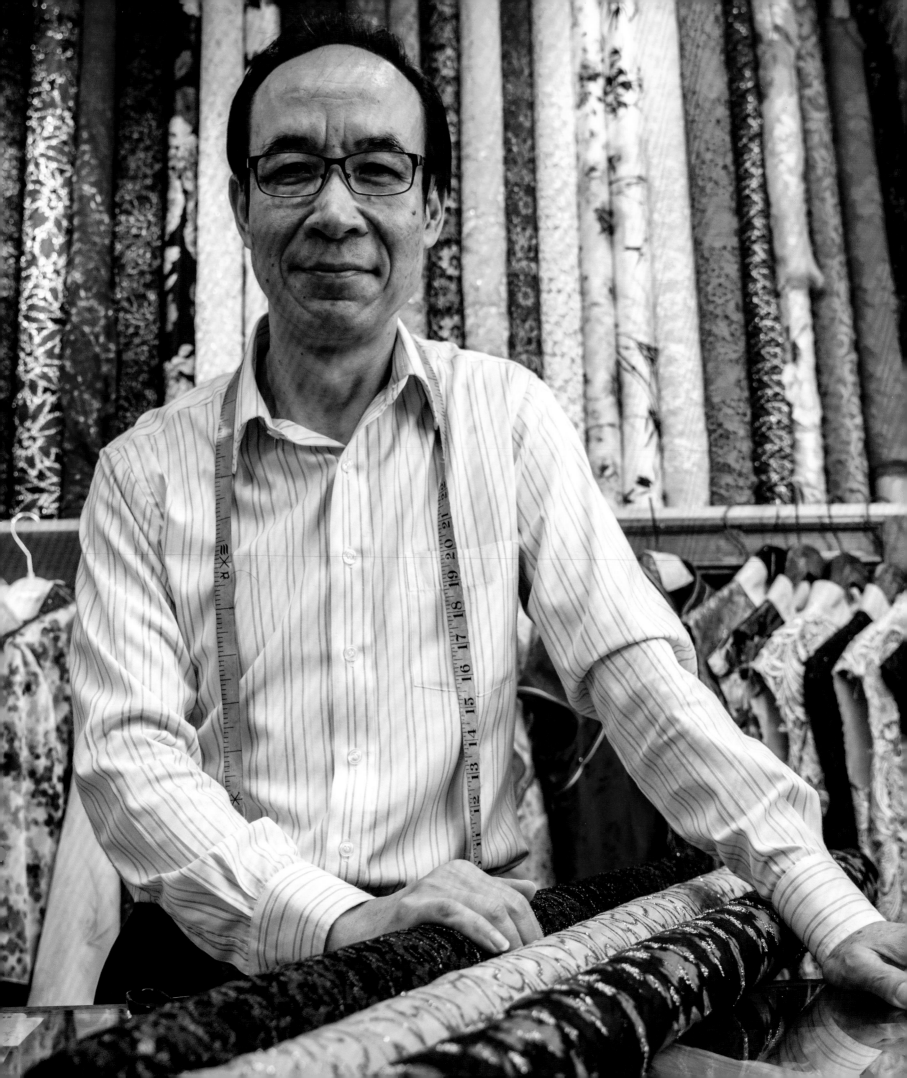

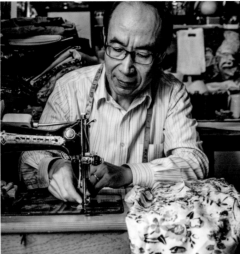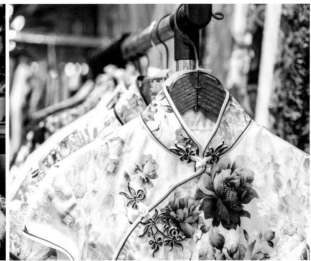

KAN HON WING 簡漢榮
OWNER AND TAILOR AT MEI WAH FASHION
美華時裝

Established in the 1920s, Mei Wah Fashion is the oldest and last remaining tailor of its kind, specialising in traditional *qipaos* and *cheongsams*. Master tailor Kan Hon Wing grew up in the shop, which was originally opened by his grandfather, and learned his trade from his father. A true lover of Chinese culture and tradition, he says he makes the garments in an effort to uphold Hong Kong's identity and values. And every piece that comes out of his shop must meet his exacting standards – with every stitch perfectly placed. Master Kan recalls the days when he and many other tailors worked in the penthouse above the shop, designing and making hundreds of qipaos every month. But now it takes him more than a week to make one qipao and says most of the tailors have retired or passed away. And with a shrinking trade comes exclusivity; while a qipao in the 1920s could cost as little as HK$1, today Master Kan's dresses can cost from HK$5,600 to HK$20,000.

"DIFFERENT QIPAO SUIT DIFFERENT PEOPLE. YOU HAVE TO SEE THEIR AGE AND PERSONALITY. EVERY QIPAO IS UNIQUE. TAILORS NEED TO BE VERY DETAIL-MINDED. I WILL GIVE PEOPLE SUGGESTIONS IF THEIR 'DREAM QIPAO' IS TOO UGLY."

"THE QIPAO IS A VERY IMPORTANT PART OF CHINESE CULTURE. IT REPRESENTS CHINA, JUST LIKE THE KIMONO IN JAPAN. THE QIPAO WOULDN'T HAVE LASTED UNTIL NOW IF IT WASN'T BEAUTIFUL."

THE INDUSTRY

The qipao, or Mandarin gown, was once everyday attire in Hong Kong. Originally worn by the Manchus during the Qing dynasty, qipaos began as loose-fitting dresses but developed into the figure-hugging svelte dress recognised in Chinese culture today. From the age of about three, young girls would be dressed in two-piece outfits and later wear the more fitted one-piece qipao. It was worn by everyone – from home to the market to work – and was not limited to social class, but wealthier families could afford better fabrics and more extravagant dresses. From the 1940s to the 1960s, Hong Kong's qipao trade was booming. The city had only two main department stores so tailors were in high demand. But times have changed dramatically in the fashion world and nowadays the qipao is reserved for more formal occasions, such as banquets or weddings. As a result, there are very few qipao tailors left in the city and those that do remain focus on creating lavish wedding or graduation dresses.

INDUSTRIES THAT HAVE ALREADY VANISHED

There are many sunset industries in Hong Kong proudly flying the flag of their ancient trades, but many have already slipped into obscurity. Older residents may recall these industries and the people who ran them from a time before the city's industrial and technological revolution.

MINING

At its peak in the 1970s, the city's mining industry employed 6,000 workers. Due to high costs, depleted ore deposits and diminishing demand for steel, all mining operations in Hong Kong were closed in 1981 and miners were forced to find other jobs.

BUS AND TRAM CONDUCTORS

Before cash boxes were installed on all buses and trams in the mid-1970s, passengers had to pay their fares to a conductor who would patrol the vehicle. The introduction of Octopus cards as a method of payment in 1997 negated the need for conductors.

RICKSHAW PULLERS OR SEDAN CHAIR COOLIES

In the 1920s, Hong Kong had nearly 3,500 rickshaws and more than 1,000 sedan chairs on the streets, all of which were pulled or carried by manpower. The vehicle was predominantly used by Westerners and the elite, and as such, became a symbol of status and colonialism. Slowly, the government stopped issuing licences and the rickshaws and sedan chairs were slowly replaced by private cars. By 1997, there were only seven licensed rickshaw pullers in the city. Today, rickshaws and sedan chairs are no longer used and can only be found in museums.

NIGHT SOIL COLLECTORS

Until the end of the 19th century, Hong Kong's sewage and sanitation facilities were hugely undeveloped. Many homes simply used pots or latrines to collect waste. The night soil collectors would collect these pots or "honey buckets" from outside houses and take the contents to the waterfront where junk boats transported the waste to collection points. Often the waste was sold to farmers as fertiliser. In 2013, it was reported that there were still five locations in Hong Kong that required the night soil collection service, however, the traditional profession no longer exists.

SALT MANUFACTURERS

The salt industry is one of the oldest known industries in Hong Kong. Salt fields were first constructed in Tai O in the mid to late 18th century. By the 1920s and 30s, salt production in Hong Kong had reached its peak, with about 102 acres of salt fields in Tai O. After the second world war, competition from foreign markets became too great and by the 1960s and 1970s all local salt operators had closed.

STONE BREAKERS

Often run as family businesses, stone breakers or cutters would labour 12 hours a day, using sledgehammers and other tools to break down large boulders into small stones. Men would normally tackle the initial boulder work before women and children bashed away at smaller pieces, which they would hold precariously between their feet. Stones would then be transported from a quarry to construction sites.

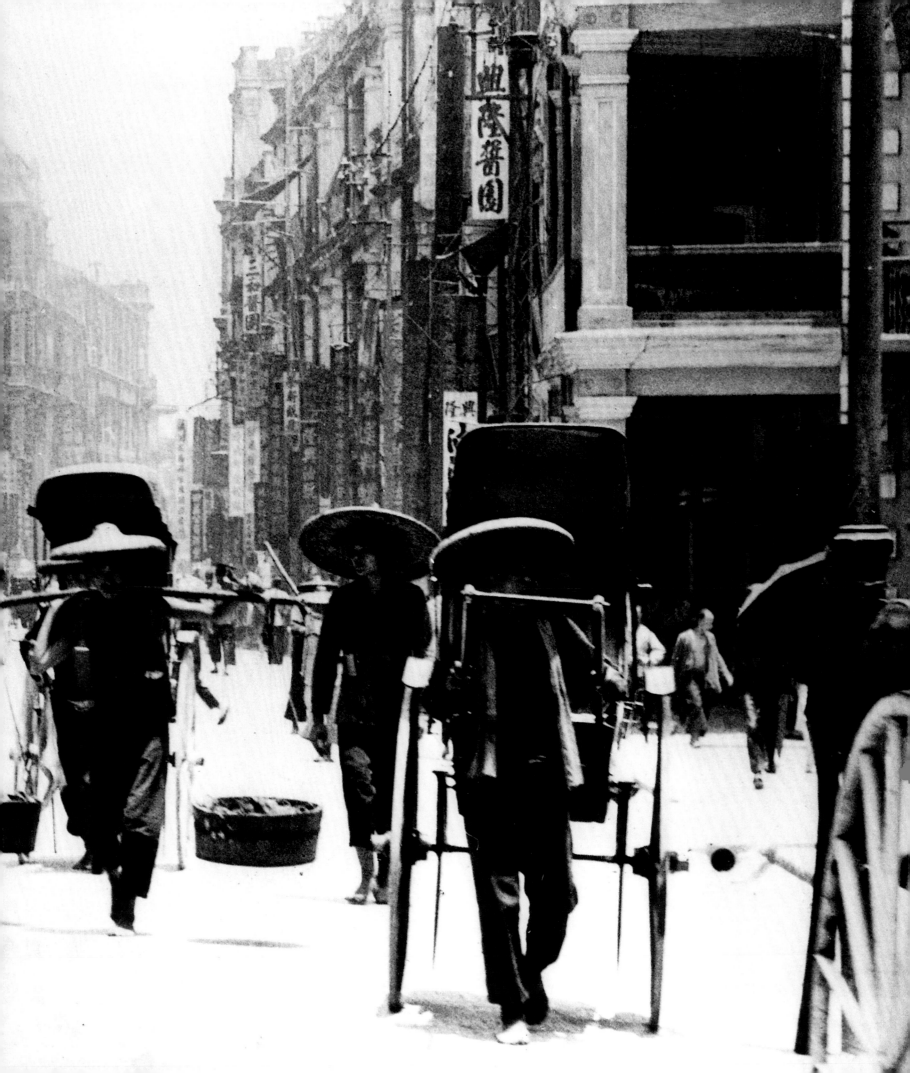

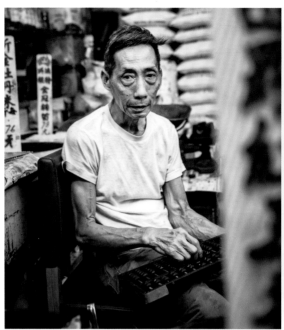
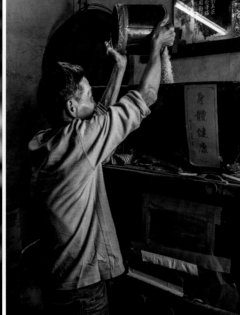
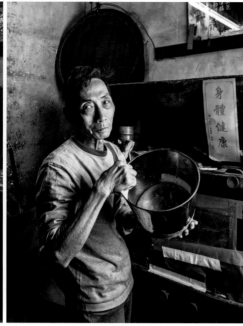

WONG TAK KAM 王德鑑
OWNER OF SHING HING TAI RICE SHOP
成興泰米行

Wong Tak Kam has worked in his family business, the Shing Hing Tai Rice Shop, since he was just 16 years old – following in his father's footsteps. He is now 73 and much of his operation remains unchanged. The shop decor looks almost exactly as it did when it opened in 1956; he has used the same rice-cleaning machine for 30 years, he serves many of the same customers every week, and he still delivers large bags of rice around Hong Kong on his 40-year-old bicycle. But the work has not always been reliable. Mr Wong recalls how modern supermarkets changed shoppers' habits and how rice lost some of its popularity when people started believing it made them gain weight. Despite his eagerness to continue serving his regulars, none of his five children want to carry on the business, and so it is likely that the Shing Hing Tai Rice Shop will shut when he retires.

"IN THE PAST, THERE WERE MORE RICE SHOPS THAN BANKS, WE COULD SEE THREE OR FOUR ALONG ONE STREET. BUT FEWER PEOPLE LIKE RICE NOW. THEY LIKE INSTANT NOODLES AND FAST FOOD SHOPS FOR QUICK MEALS NOWADAYS."

"I CYCLE TO TSIM SHA TSUI AND YAU MA TEI DISTRICTS. I CAN'T DELIVER THE RICE BY MTR AS THE BAGS ARE TOO BIG."

THE INDUSTRY

Independently owned rice shops were once the only way to buy the staple food in Hong Kong, with some 4,000 scattered across the city by the 1970s. Shops were lined with huge sacks or wooden tubs of the grain – in different textures and ages – and rice masters helped customers choose the right blend. Much like tea, selecting rice was a rather personal thing: elderly people often preferred softer, easily digested grains while others chose older, harder rice so they felt full faster. But with the introduction of modern supermarkets in the 1980s and prepackaged groceries, the once-thriving local rice shop industry was all but destroyed. Today there are fewer than ten traditional sellers left in the city, mostly around Yau Ma Tei, Kowloon City or Sai Ying Pun.

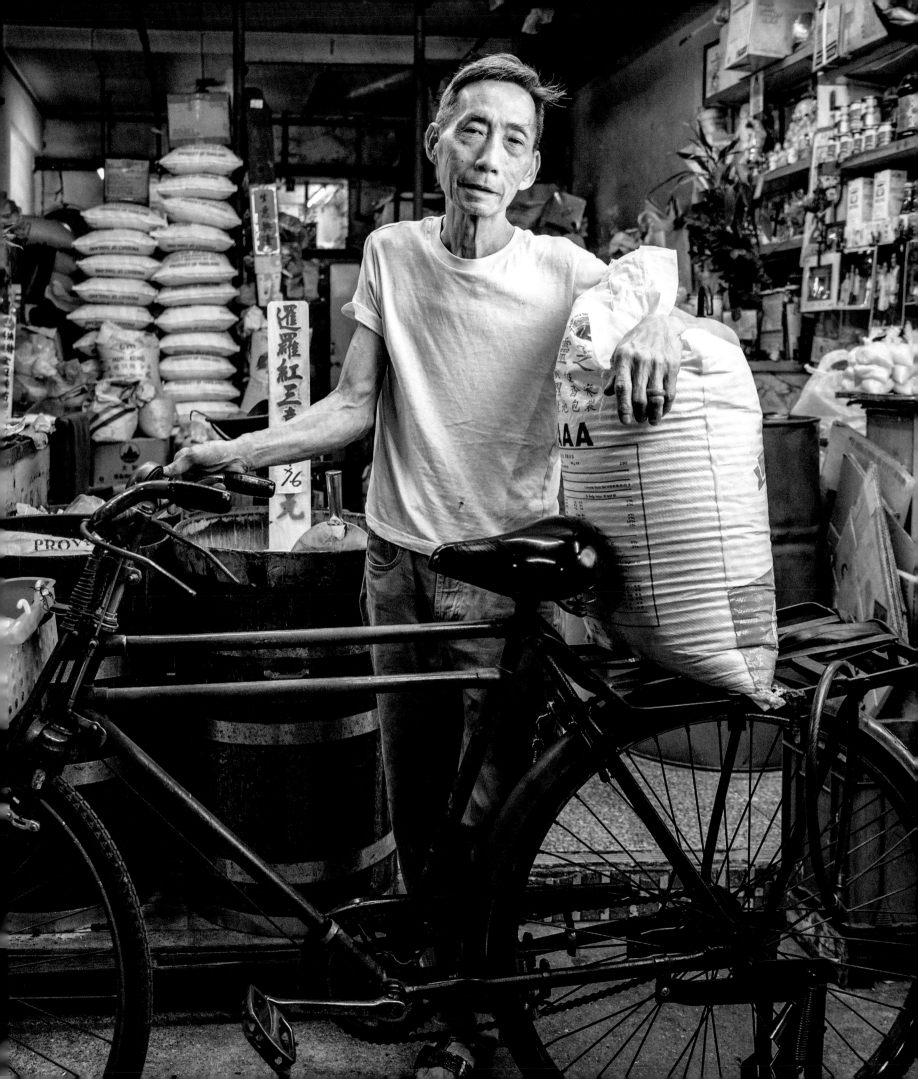

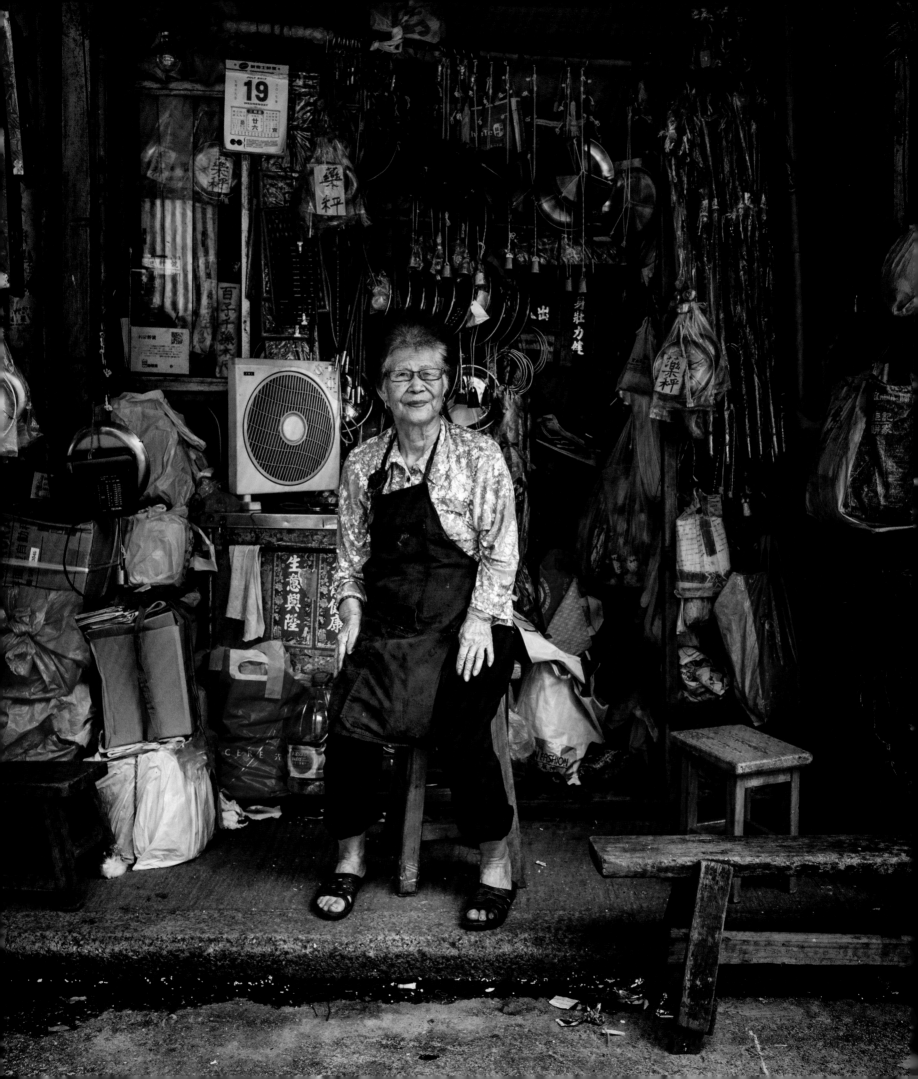

MRS HO 何太
OWNER OF LEE WO STEELYARD
利和秤號

 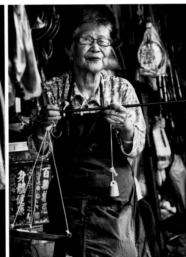

Mrs Ho is the petite elderly owner of Lee Wo Steelyard, a hawker stall down an alleyway in Yau Ma Tei. It has been operating for 90 years and was once run by her father, who taught her how to handcraft the traditional scales when she was just 12 years old. With declining business and deteriorating eyesight, Mrs Ho relies on the help of an old friend to make the scales and spends much of her time now listening to Chinese opera on the radio, remembering the days when the shop would be busy with orders. Although, she says, fewer people know how to use the scales, she still has a handful of loyal customers. An ordinary set costs about HK$200 whereas the largest, which fishermen use to weigh their catch, costs HK$980. Mrs Ho's children want her to retire, but she says she still enjoys her work and chatting to customers too much to step aside. Plus, she always finds time to spend with her grandchildren.

"I HAVE A SET OF THESE SCALES AT HOME. I USE IT TO CHECK IF THE MEASUREMENT IN THE WET MARKET IS CORRECT. THE PEOPLE FROM THE WET MARKETS SOMETIMES LIE ABOUT THE WEIGHT OF THE GOODS!"

"THESE TRADITIONS ARE DEFINITELY FADING. NO ONE LEARNS TO MAKE THESE SCALES NOW. EVEN MY CHILDREN ARE NOT INTERESTED IN LEARNING. ONLY ME AND ONE OTHER STORE IN HONG KONG ARE SELLING THESE TRADITIONAL SCALES."

THE INDUSTRY

Traditional Chinese scales are made from a wooden rod with a metal plate or hook and a counterbalance weight, which slides across until the scales are level. Nowadays, the simple instrument is most commonly used to weigh Chinese medicine or food, but in the past, anything from gold to silver or even opium were weighed. The scales are not as common today as they once were, with many shop owners now using more modern and precise spring-balance or digital versions – good for shoppers who want to avoid being scammed. But many traditional industries such as Chinese doctors and wet market workers still use the old-fashioned scales.

GAO TAK TIN 高德田
MASTER BARBER AT THE KIU KWUN SHANGHAINESE BARBER SHOP
上海僑冠男女理髮公司

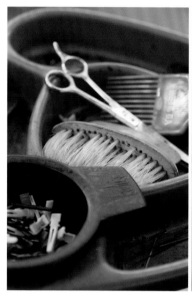 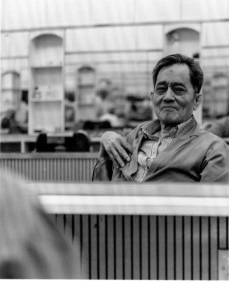 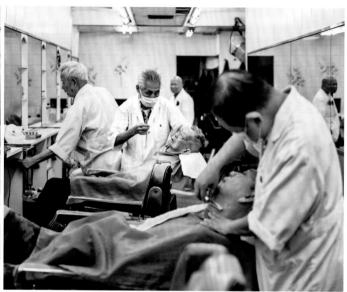

Mr Gao arrived in Hong Kong in 1959 and settled into a squatter village with his family. At just 14 years old, he picked up his father's tools and learned the family trade, first practising his blade skills on a watermelon to ensure he would not hurt his customers. He has proudly worked as a barber for more than 55 years and fondly recalls the days when he was entrusted to cut the hair of celebrities, including the famous Kwok brothers of Sun Hung Kai Properties and their father. Today, Kiu Kwun Barber Shop is one of a handful of shops that still provide the distinctive Shanghai-style service in Hong Kong. In fact, his is the oldest and largest remaining in the city, with 14 employees all over the age of 70. A standard haircut, including the famous 'Egg Tart' style, and a straight razor shave costs HK$70.

"CURLY HAIR WAS ONCE SO POPULAR THAT EVEN PEOPLE WITH SHORT HAIR WOULD CURL IT. EVERYONE CAME FOR A PERM BECAUSE THEY COULDN'T DO IT AT HOME. HOWEVER, THE TREND HAS CHANGED AND MOST PEOPLE PREFER STRAIGHT HAIR NOW."

"WE ARE THE LAST GENERATION OF SHANGHAINESE BARBERS IN HONG KONG. HOWEVER, WE ARE ALL GETTING OLD AND MANY HAVE EITHER RETIRED OR PASSED AWAY."

THE INDUSTRY

Set up after the Chinese Civil War ended in 1949, when workers from Shanghai flooded Hong Kong, these barber shops were famous for giving classic haircuts to the city's super trendy. A far cry from today's barber shops, these masters of the craft used manual clippers and straight blade razors, trimmed men's nose and ear hairs, clipped nails, gave massages and shined shoes. But with the arrival of modern salons and powered hairdressing tools in the 1970s, the industry soon fell into decline and fewer young people chose to learn the practice. Now, only a handful of shops in Hong Kong continue to provide the distinctive service.

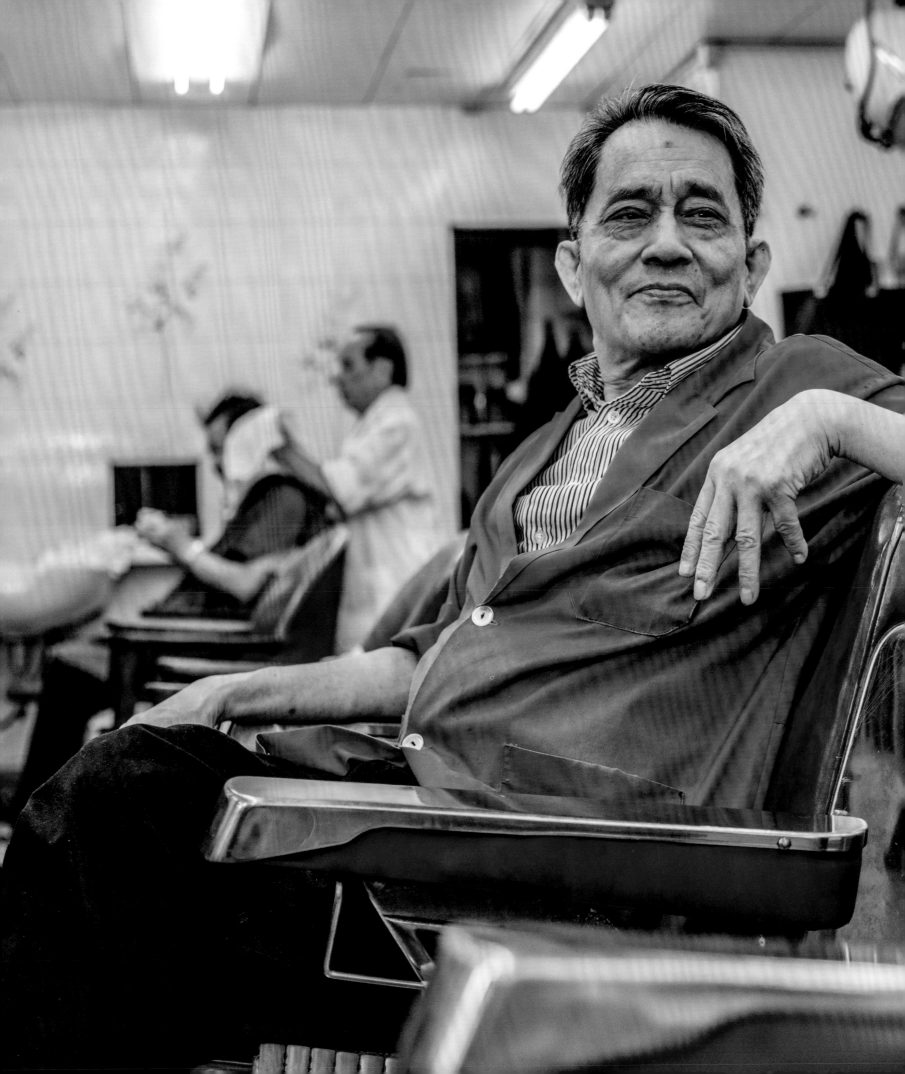

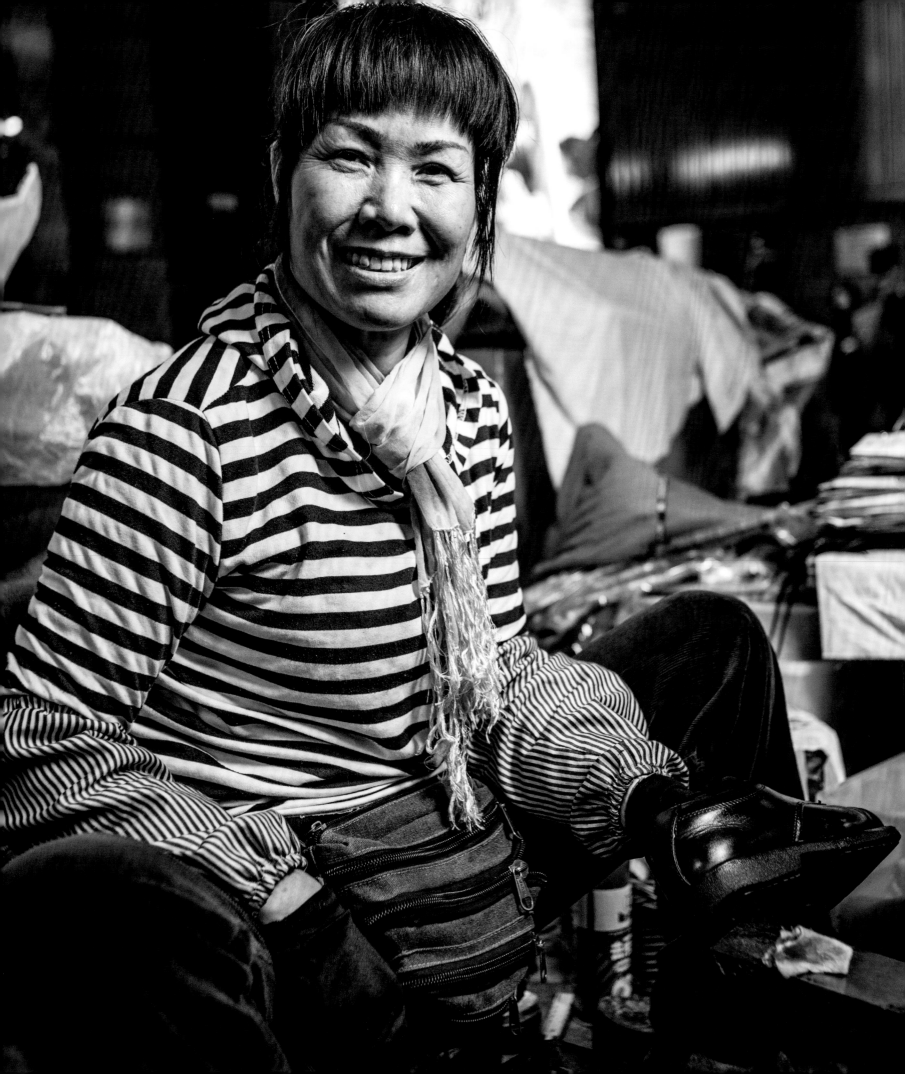

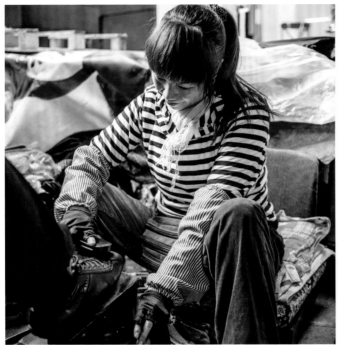

MRS DAI 戴太
SHOE SHINER

Mrs Dai emigrated from China in 2010 to join her husband who had worked in Hong Kong for more than 20 years as a shoe shiner on Theatre Lane in Central. But just 10 months after she moved, he passed away, leaving her the licence. Despite the sorrowful turn of events, Mrs Dai has remained as jovial as ever. Her smile is cheeky and her setup modest; a small plastic stool for her, an office chair for customers, some tubs of polish and old bristly brushes, including a blackened toothbrush, do just fine. Though Mrs Dai appreciates the freedom of the work, shining up to 20 pairs of shoes five days a week for HK$40 a pair has taken a toll on her body. Crouching over customers' feet has led to a bad back and aching knees. And while most clients just stare at their phones, she says a few still like to chat.

"I HAVE NEVER DONE ANYTHING WRONG TO A CUSTOMER'S SHOES. BUT I HAVE HAD COMPLAINTS THAT THE SHOES AREN'T SHINY ENOUGH. I THINK IT'S UNACCEPTABLE TO MAKE MISTAKES AS WE JUST APPLY THE SHOE POLISH ACCORDING TO THE COLOUR OF THE SHOES. I WON'T PUT BLUE POLISH ON A BLACK SHOE!"

"IN THE PAST PEOPLE CHERISHED THEIR SHOES. NOWADAYS PEOPLE CARE LESS ABOUT THEIR SHOES UNLESS IT'S A REALLY EXPENSIVE PAIR."

THE INDUSTRY

Hong Kong's shoe shining industry originated in the early 1900s and picked up speed after the war when sleek Western businessmen began arriving. Today, the industry is on the brink of extinction. Shoe shiners require a hawker licence, which can only be passed to immediate family members, and no further applications are accepted. Consequently, as these licence holders grow old and pass away, so do the licences, taking a slice of Hong Kong's culture with them. There are some unlicensed practitioners, but if caught by authorities, they face hefty fines. And in today's throwaway culture, fewer people treasure the longevity of their shoes.

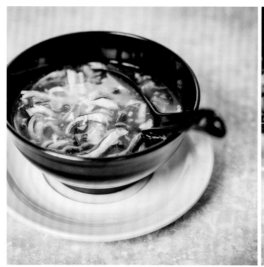
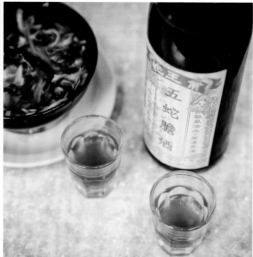

GIBSON CHEUNG 張傑生
OWNER OF SHER WONG YIP SNAKE SOUP RESTAURANT
蛇王業

Gibson is the third generation owner of his family's snake soup restaurant in Sham Shui Po. Founded by his grandfather more than 70 years ago and still dishing up all the classics including snake gallbladder in rice wine, Sher Wong Yip restaurant is one of just 20 such shops in the city. Live snakes were traditionally kept in crates around the shop, so they could easily be slaughtered, skinned and cooked to order. But nowadays only a small number are kept on hand, with the vast majority of meat being imported frozen from Southeast Asia. Gibson, who spent many years living in Canada, says he prefers it this way because he is an animal lover and cannot bear to kill the snakes himself. His father, however, is far more traditional and has no trouble removing the fangs or slicing open their bellies to take out the gallbladders.

"TRADITIONALLY, WE USE THE LIVER, BLOOD, SKIN, VENOM AND THE BONES FOR MAKING SOUP AND ALL SORTS OF SNAKE DISHES. WE ALSO SUCK OUT THE JUICY BILE FROM THE GALLBLADDER. IT HELPS TO SOOTHE SYMPTOMS LIKE PHLEGM BUILD UP, AN ITCHY THROAT AND BRONCHITIS."

"WHEN I CAME BACK TO HONG KONG, I HAD A HARD TIME ADJUSTING TO THE SMELL, AND SEEING SNAKES BEING KILLED. BUT EVENTUALLY I GOT TO A POINT WHERE I REALISED IT WAS JUST A BUSINESS. I KNOW THAT MOST PEOPLE DON'T AGREE WITH WHAT I DO, BUT I'M JUST TRYING TO SURVIVE."

THE INDUSTRY

For more than 2,000 years, snake soup has been a popular Chinese delicacy. Once considered a food of high society because it represented wealth, bravery and respect, today the HK$60 bowl of soup has a far less glamorous reputation. Containing two separate kinds of snake and eaten in winter to warm the body and fend off sickness, it is said to have numerous health benefits, particularly for the elderly. A bottle of snake gallbladder rice wine contains 15 to 25 gallbladders. But the industry now faces multiple challenges, including scepticism towards the meat's actual health benefits and ethical criticisms about farming and the consumption of snakes.

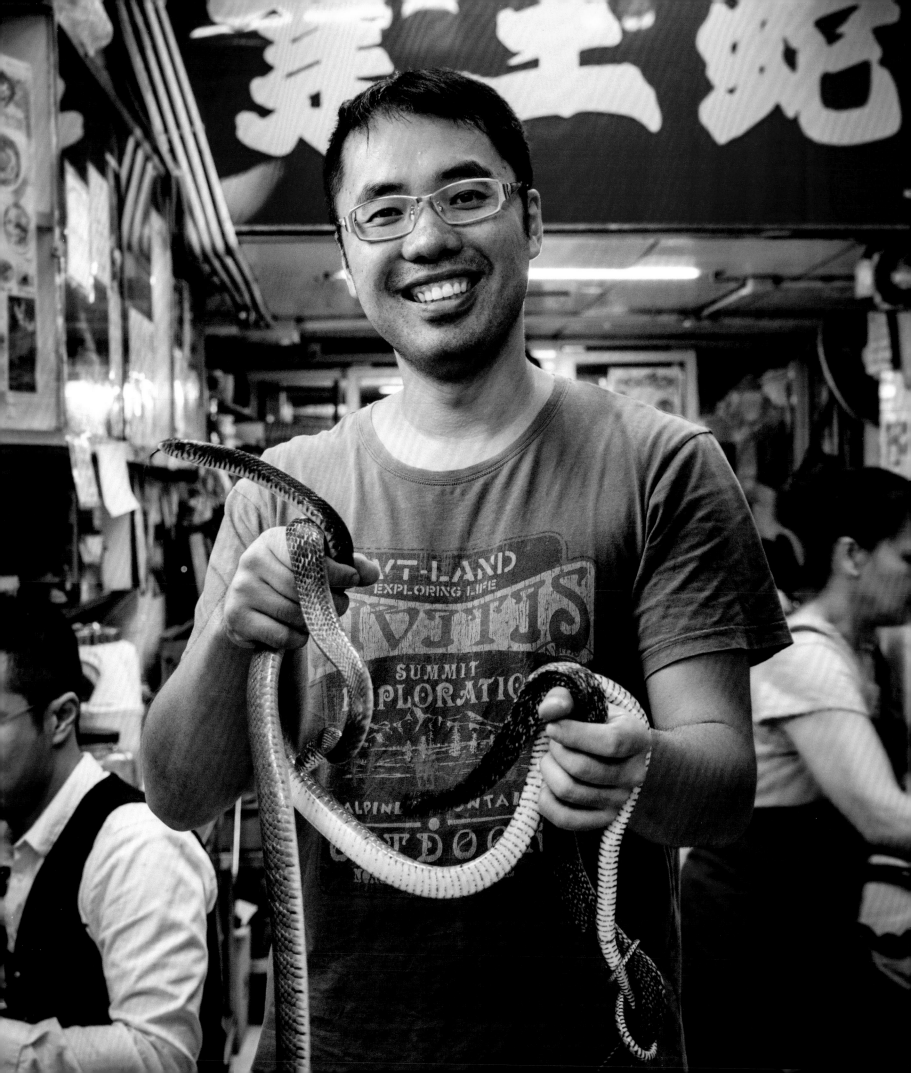

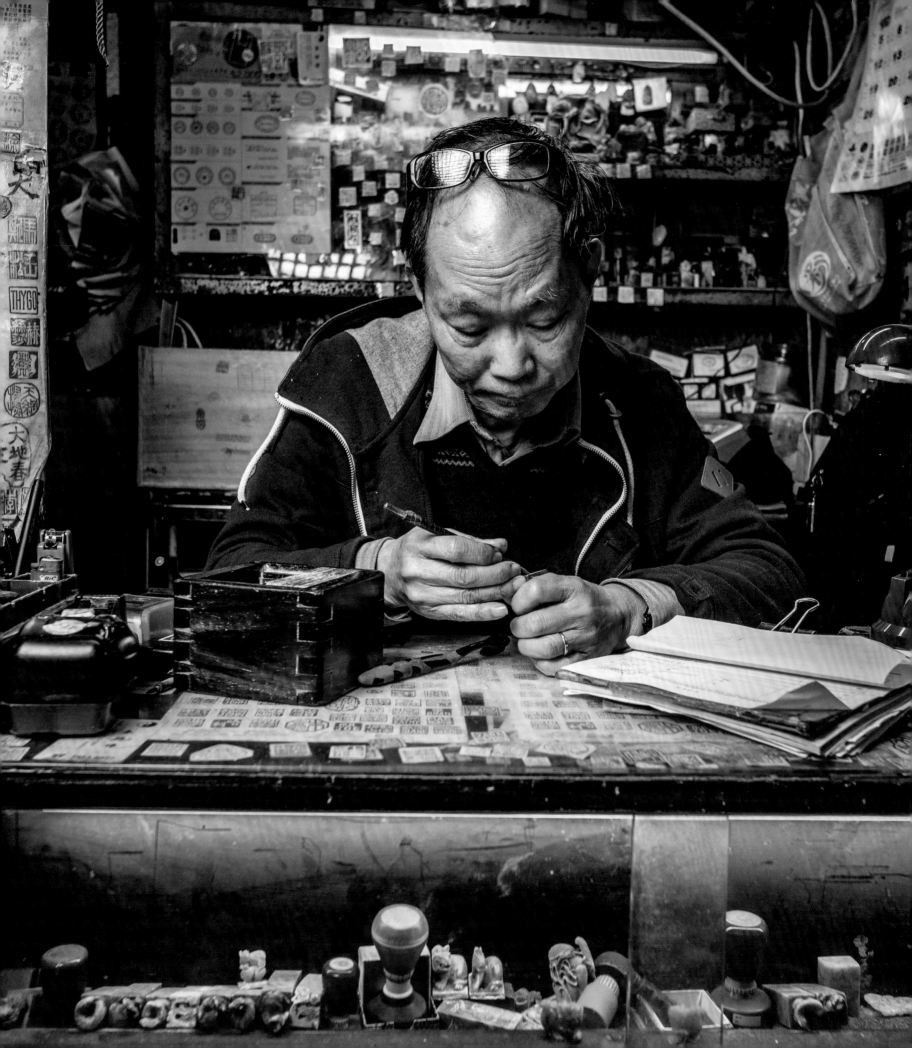

MAK PING LAM 麥炳霖
TRADITIONAL CHINESE SEAL MAKER AT TIN KEUNG STAMP SHOP
天強印章

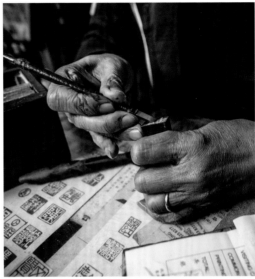
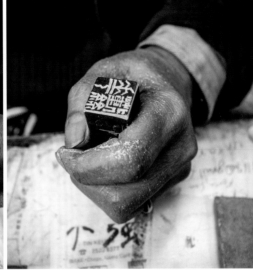
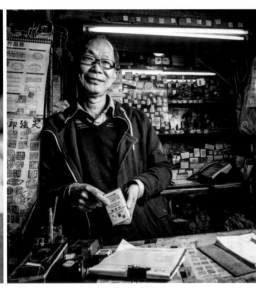

Mak Ping Lam started making Chinese seals at the age of 19. Today, the 68-year-old is a master of engraving stone seals. Having learned the skill from his brother-in-law, he passed on the knowledge to his son, who works with him. His friendly personality along with his fluent English are a testament to the many people he has met over the years. Despite having been in the business for half a century, he has kept his tools simple: a few rusty knives, a small wooden vice, one scrap of sandpaper and the bottom half of a soda can as a ink tray. To make a seal, he finds the appropriate traditional Chinese characters for the job, drafts a 2cm by 2cm design, and draws a mirror image of it onto the base of the seal. Only then can he begin to etch it into stone. He must also find the best *feng shui* for the characters. While he concedes that the work does not pay well, he finds it interesting and enjoys the lifestyle.

"BEST THING ABOUT MY JOB? MY LIFE. I DON'T THINK ABOUT MONEY ANY MORE. MY LIFE IS OK. ARTISTS ALWAYS HAVE DIFFICULTY MAKING MONEY."

"SOME FORTUNE TELLERS TELL PEOPLE TO COME HERE, MAKE A CHOP TO PUT ON THEIR DESK AND THEY WILL GET GOOD LUCK. I DON'T KNOW IF IT WORKS OR NOT. I ONLY MAKE THE CHOPS! I'M NOT A FENG SHUI MASTER. BUT WHY DON'T YOU BUY ONE AND FIND OUT?"

THE INDUSTRY

Traditional Chinese seals or 'chops' date back to the Shang Dynasty, which ruled from 1600 BC to 1046 BC. Since then, they have been used as a form of identification for documents, legal papers, bank transfers and anything requiring authorship. Today, seals are still used in lieu of a signature on cheques in mainland China and Taiwan, but not in Hong Kong. Theoretically, the seal should only be accessible to the owner and, as it is handcrafted, can never be replicated. They were traditionally made from jade or other rare stones, but today cheaper soapstone is more common. While seals are still widely used across Asia, they are popular in Hong Kong as souvenirs for tourists.

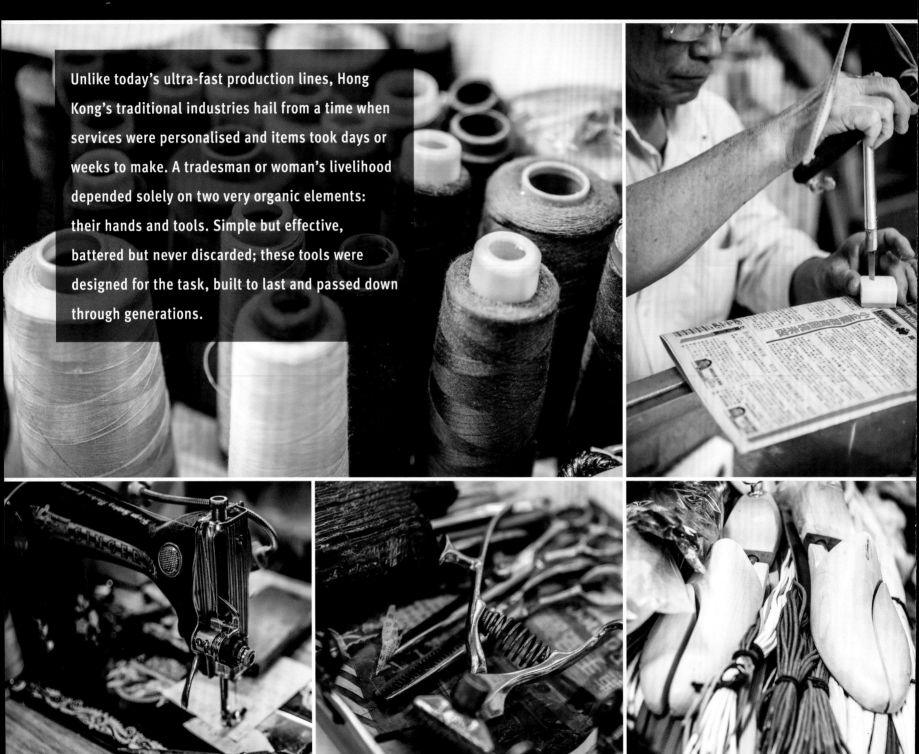

TOOLS OF THE TRADE

Unlike today's ultra-fast production lines, Hong Kong's traditional industries hail from a time when services were personalised and items took days or weeks to make. A tradesman or woman's livelihood depended solely on two very organic elements: their hands and tools. Simple but effective, battered but never discarded; these tools were designed for the task, built to last and passed down through generations.

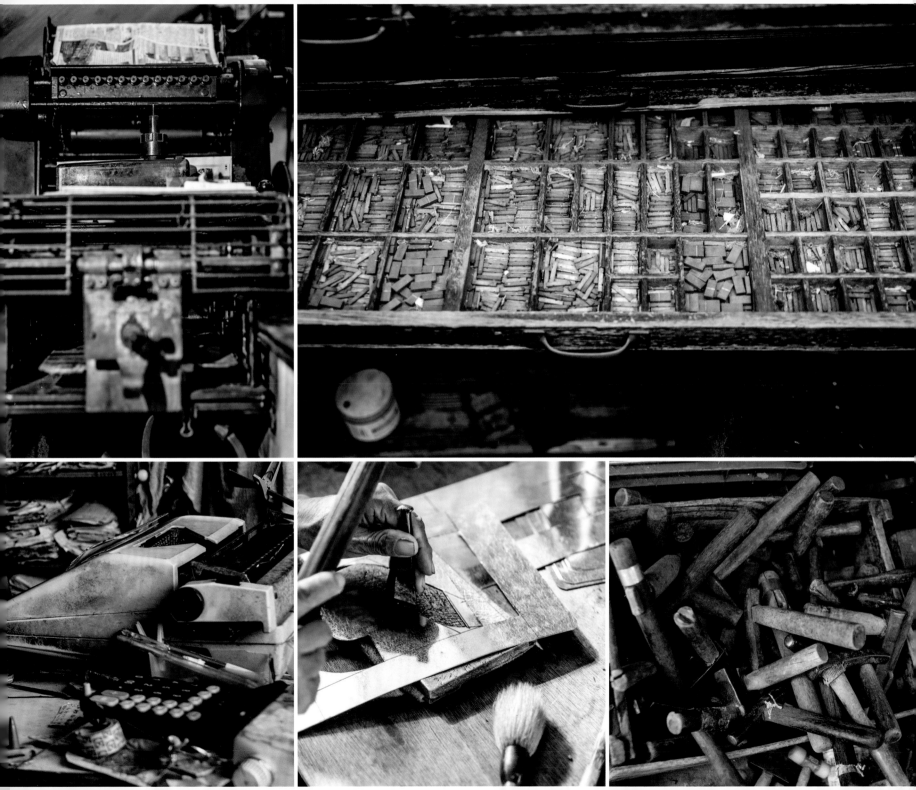

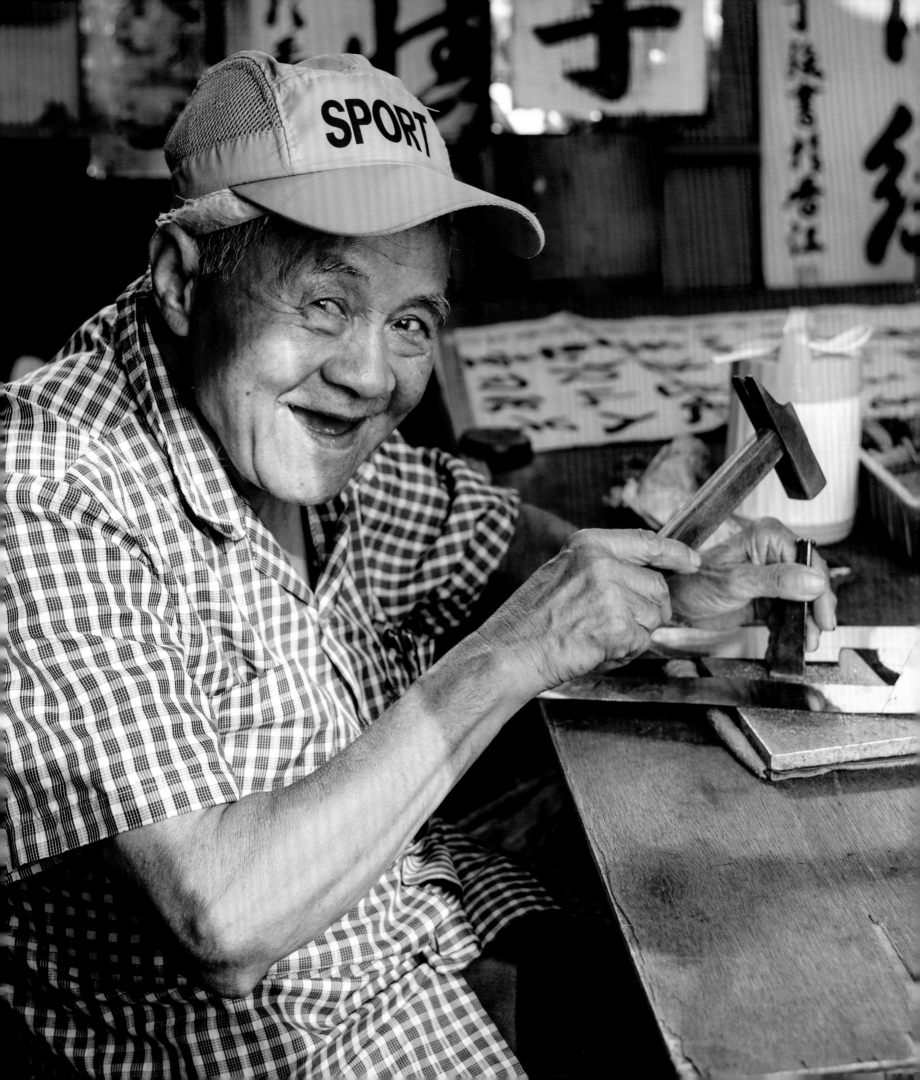

WU DING KEUNG 胡丁強
STENCIL MAKER

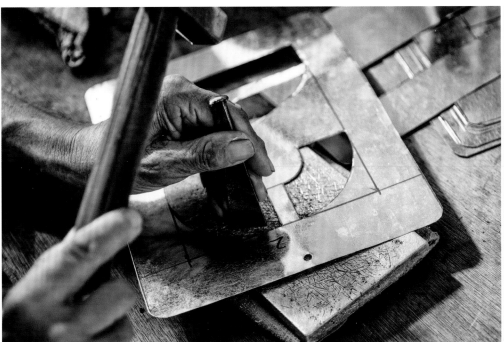
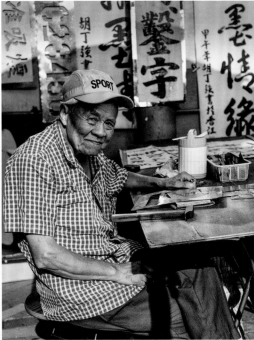

Wu Ding Keung is one of Hong Kong's last stencil makers. The 82-year-old, with his toothless smile and wrinkled hands, has worked on the corner of Argyle Street, Mong Kok, under his blue parasol for more than 30 years. Stooped over a small table with only a hammer and bag of chisels, evidence of Keung's stoicism and passion for Chinese literature surround him. Hand-written Chinese calligraphy is proudly displayed around his stall and an old notebook bursting with sketches and customer details lays on the table. He admits days can go by without a single customer, but he continues to work to keep himself busy. And despite the notable lack of business, he still seems to have many jobs to do. After all, it can take up to three days for him to complete just one piece.

"I'VE FORGOTTEN HOW LONG I'VE BEEN WORKING HERE, BUT I KNOW I STARTED BEFORE THE HANDOVER OF HONG KONG."

"I ONCE HELPED A COUPLE MAKE A STENCIL FOR THEIR WEDDING PARTY. I LIKED THAT."

THE INDUSTRY

Stencil making is among Hong Kong's oldest trades and was once a thriving industry with dozens of workshops lining the streets of Mong Kok. The delicate process requires a sharp eye and steady hand, expert calligraphy skills and a great deal of patience. Craftsmen first draw the Chinese characters onto thin iron sheets, then very carefully cut them out with a hammer and chisel. These hand-cut stencils were the most popular choice for advertising, wall notices and shop signs, but today they have been largely replaced by digital productions or laser cutting. As a result, there are only two stencil tradesmen left in Hong Kong, both running their stalls side by side on Argyle Street.

'DAI GA ZE' 大家姐
TEMPLE STREET KARAOKE MANAGER

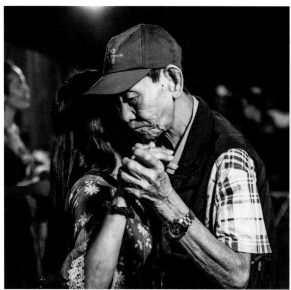 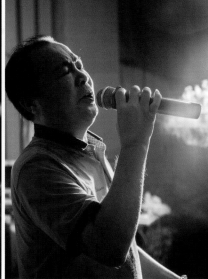 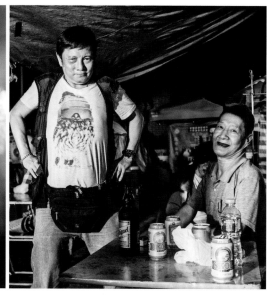

'Dai Ga Ze', or 'big sister' as she is affectionately known, has been helping run this particular karaoke booth for more than 10 years since she retired from working in a mechanics factory. The booth has been open to amateur singers and professionals for more than 30 years, firing up the microphones at 7.30pm and pulling the plug at 11pm. Every night, Dai Ga Ze welcomes all manner of people inside her tarpaulin tent to sing their song of choice and drink countless cans of beer. She is busy every night and hardly has a minute to sit down as the songs keep coming and the queue keeps growing. Whether her customers are elderly couples looking for a place to have a romantic dance, or drunk leather-clad gangsters looking to bellow out a Canto classic, she casts no judgment, but simply enjoys watching them have fun.

"I COME HERE EVERY NIGHT, IT'S DEFINITELY MY FAVOURITE THING TO DO IN HONG KONG. I SING FIVE SONGS AND DRINK FIVE BEERS. I LOVE IT HERE AND FEEL SO HAPPY WITH THE PEOPLE HERE. THEY ARE ALL LIKE FAMILY TO ME!"

Nelson Chung, nightly street karaoke singer

"I THINK THIS KARAOKE AREA DEFINITELY REPRESENTS THIS PART OF HONG KONG. I ALWAYS SEE TOURISTS STOPPING AND LOOKING AT US WHEN THEY PASS BY. THIS IS THE CULTURE OF TEMPLE STREET AND I THINK THE CULTURE WILL LAST IN OUR HEARTS FOREVER!"

THE INDUSTRY

Karaoke has long been a favourite pastime for Hongkongers looking to let off steam at the end of a long day at work. But the real fanatics are found in the streets around Temple Street market, performing Chinese opera classics and Cantopop hits for anyone who will listen. While most come for enjoyment, some singers aspire to follow in the footsteps of Anita Mui – dubbed the 'Madonna of Asia' – who started singing on Temple Street at just five years old and went on to sell more than 10 million albums. Despite the applause from fellow singers, they often receive complaints from residents. And with plans afoot to reopen the road to vehicles, they are at risk of closing down.

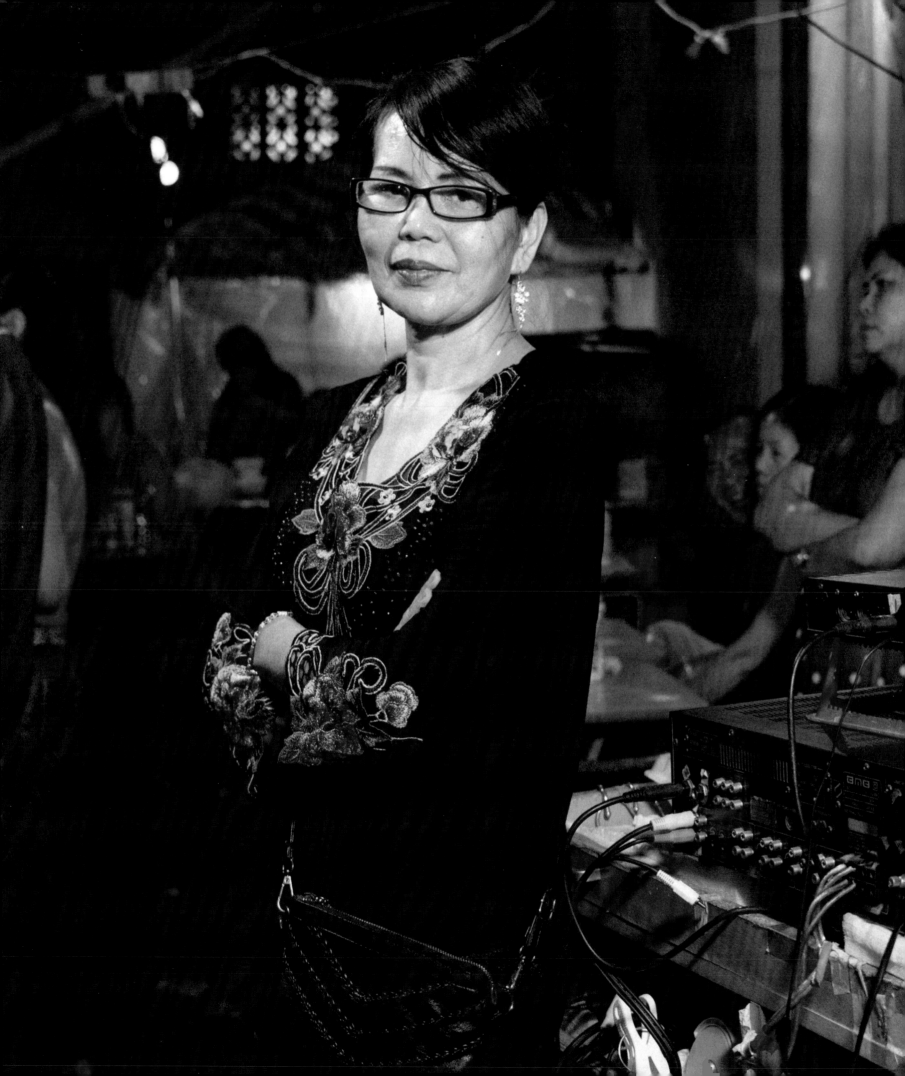

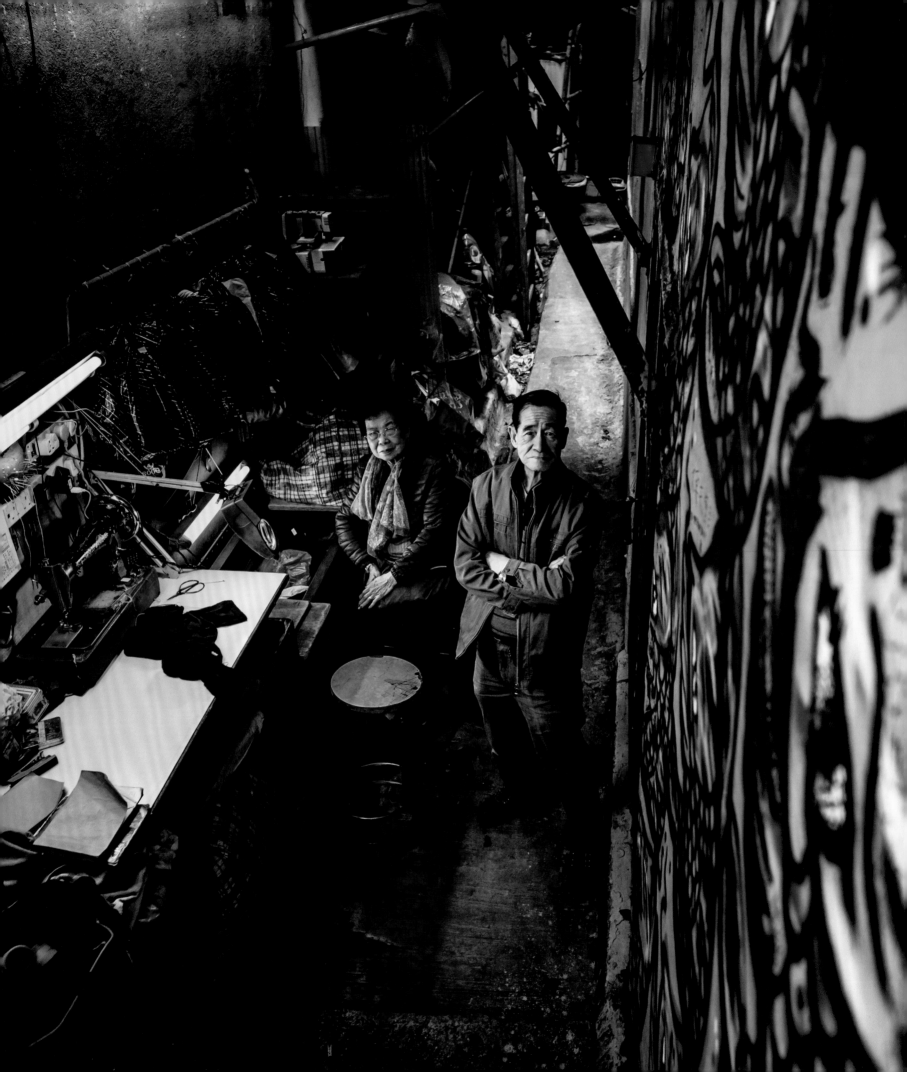

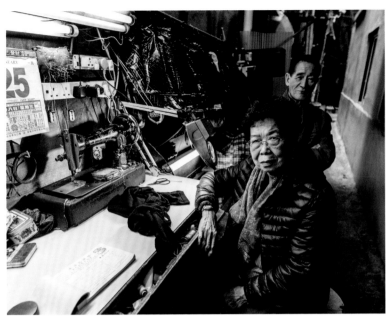

LEE PING HONG 李炳康
TAILOR AT LEE CHAM'S SHOP
李湛記織補

Down a graffiti-covered alleyway in Sai Ying Pun, Lee Ping Hong and his wife have been running their clothing repair service for more than 60 years. An endearingly close couple who laugh at each other's jokes, it is clear to see why they work so well together. Huddled around one ancient sewing machine, the two octogenarians work every day to fix anything from damaged sweaters to children's dolls. Each piece takes about a week to fix. Like many of Hong Kong's dying industries, they come from a time when things were repaired, not thrown away. And while theirs might not be a contemporary profession, they still receive apprenticeship requests. But the couple, who have no plans to retire, say they have too much work and not enough time to pass on their skills. They also do not believe anyone with a decent education would want to learn, or have the patience to master such a low-income craft.

"IT CAN COST YOU NEARLY HK$7,000 TO BUY A GOOD CASHMERE SCARF, BUT THEY CAN BE EASILY TORN BY AN EARRING WHEN YOU TAKE THEM OFF. SO WE HAVE CUSTOMERS COMING NEARLY EVERY DAY."

"WE ARE HELPING INDIVIDUAL CUSTOMERS AS WELL AS COMPANIES. LAUNDRY SHOPS COME VERY FREQUENTLY WHEN THEY ACCIDENTALLY DAMAGE CUSTOMERS' CLOTHES."

THE INDUSTRY

In the 1950s, tailors and pop-up clothes repair shops were on every Hong Kong corner. A pair of leather shoes or a hand-embroidered dress would have cost a lot of money and likely be treasured for years. Chain alteration shops or upmarket repair shops did not exist and few people had a domestic helper with the knowledge and skill to mend clothes – cheap street tailors were a necessity. While a handful of small clothing repair shops remain in Hong Kong's markets and malls, very few people are still truly dedicated to the specialised work and even fewer want to learn the craft.

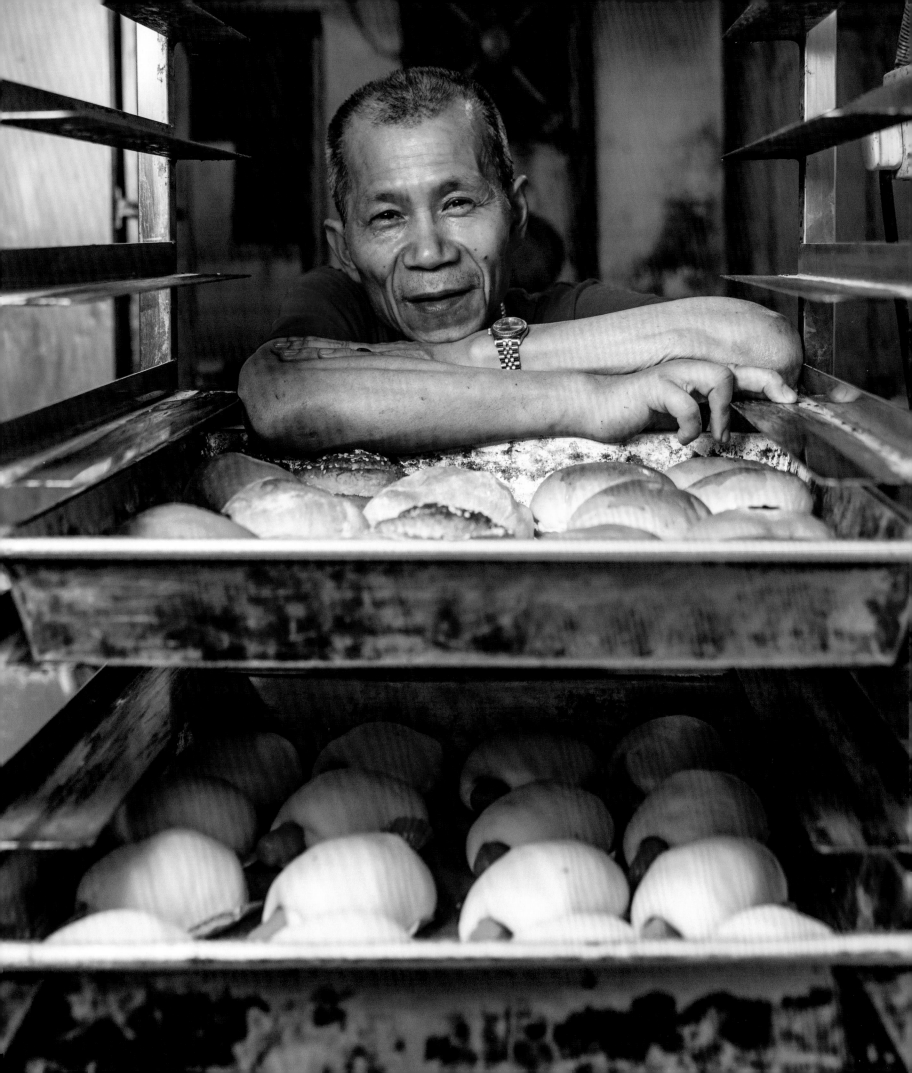

WONG SIU-PING 黃少平

OWNER OF HAPPY CAKE SHOP
快樂餅店

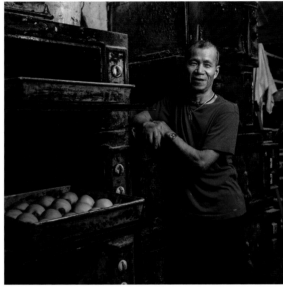

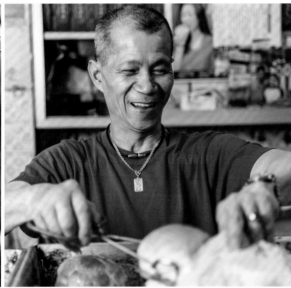

Wong Siu-ping has worked as a baker since he arrived in Hong Kong in the 1970s. He had never baked while growing up in Shenzhen, or even used an oven. In fact, he did not particularly like bread. Nevertheless, he took over the Wan Chai business soon after a relative introduced him to baking, and named the shop after the feeling it brought him and his wife. From midnight, doughs are mixed and kneaded for a myriad different buns and cakes before being set aside to prove and then bake – just in time for the 6am rush. While *bolo bao* is always a favourite, Mr Wong also makes Hong Kong classics such as wife cakes, cream buns, palmiers and egg tarts. And although it is now the oldest shop on the Queen's Road East strip, this tiny bakery remains one of the most popular with local school children and office workers.

"I LOVE TO CHAT WITH MY CUSTOMERS AS THEY ARE ALL MY FRIENDS. I FEEL PROUD WHEN PEOPLE APPRECIATE THE BREAD I MAKE. I AM VERY SATISFIED IN MY LIFE AND I LOVE WHAT I AM DOING NOW."

"I DON'T REALLY WORRY ABOUT THE END OF THE SHOP. THINGS MUST COME TO AN END, LIKE OUR LIFE. I UNDERSTAND THAT THE DAY WILL COME AND I WILL ENJOY MY RETIRED LIFE BY THEN. YOU SEE THINGS DIFFERENTLY WHEN YOU GET OLDER."

THE INDUSTRY

Hong Kong bakeries are stacked with butter-based, sweet, soft bread and other dessert-like treats. Though some Westerners might complain about the absence of French-style baguettes, true Hongkongers cannot resist the lure of a fresh egg tart or bolo bao. Bread and cake-making in Hong Kong dates back to when tea houses would produce Chinese sweets wrapped in ornate boxes and dim sum restaurants would steam the famous white buns. Since the early 1900s, when Western influence started to proliferate, many independent bakeries began to produce East-meets-West-style cakes, biscuits and bread. But nowadays the industry is largely dominated by chain stores.

TSUI MAN PAN 崔文斌
OWNER OF KUNG LEE HERBAL TEA SHOP
公利真料

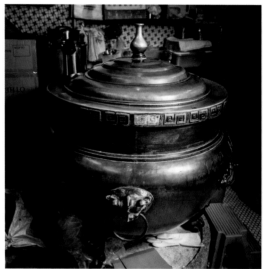 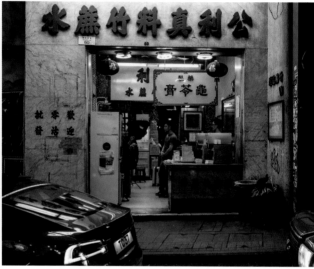

Among the modern shops and trendy bars of Hong Kong's hip Hollywood Road sits Kung Lee Herbal Tea Shop, a 70-year-old establishment now run by the fourth consecutive generation of its family owners. The shop serves traditional classics such as 24-herb tea, cane juice and turtle shell jelly. The shop was opened in 1948 by a landowner who ran sugarcane fields in Yuen Long. Back then, a cup of cane juice cost just 1 cent. Tsui Man Pan and his family live in the flat above the shop and each day he helps his father and brother by steaming and crushing around 100 stalks of sugarcane through their 30-year-old mill. They sell an average of 100 bowls of turtle shell jelly daily. The shop decor has remained unchanged since the 1950s and it has become renowned for its nostalgic Hong Kong charm. Tsui has been drinking cane juice and eating turtle shell jelly since he was a little boy and firmly believes in their cooling, detoxifying properties.

"WE USED TO EAT THE WHOLE CANE. WE WOULD CHEW IT AND SPIT THE REMAINDER OUT AFTERWARDS. WHEN I WAS YOUNG, I CHEWED TOO HARD AND MADE MY GUMS BLEED. BUT PEOPLE ARE MORE CONCERNED WITH HYGIENE NOW AND IT'S TOO TROUBLESOME FOR THEM TO EAT."

"WE ARE ONE OF THE OLDEST HERBAL TEA SHOPS IN HONG KONG, SO WE HAVE MANY OLD CUSTOMERS. THEY OFTEN BRING THEIR CHILDREN AND EVEN GRANDCHILDREN."

THE INDUSTRY
Cane juice and turtle shell jelly were once common streetside delicacies around Hong Kong. Cane juice is made by crushing a stick of sugarcane and passing it through a mill. Twenty years ago, Hong Kong's streets were lined with vendors selling the juice and bins full of the mangled remains of cane sticks. While some local shops still process and sell the juice, the industry has been largely replaced by sugar-loaded soft drinks. Turtle shell jelly or *gwai ling go* is a Chinese medicine sold as a dessert and is traditionally made from the plastron (bottom shell) of the endangered Golden Coin turtle mixed with various herbal ingredients. Today, the cost of a single turtle is nearly HK$10,000, so most jelly is made with a shell powder from a much cheaper and more common turtle. The near-black jelly is thought to help detoxify the body.

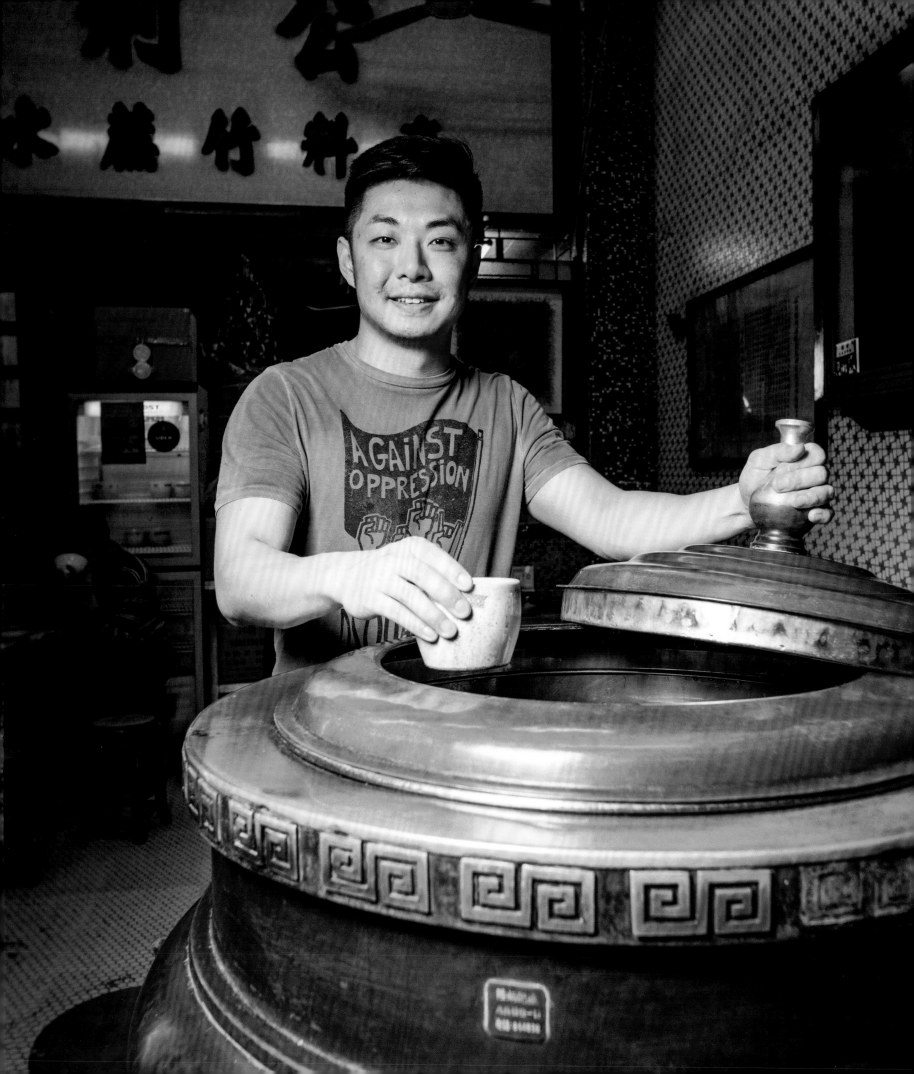

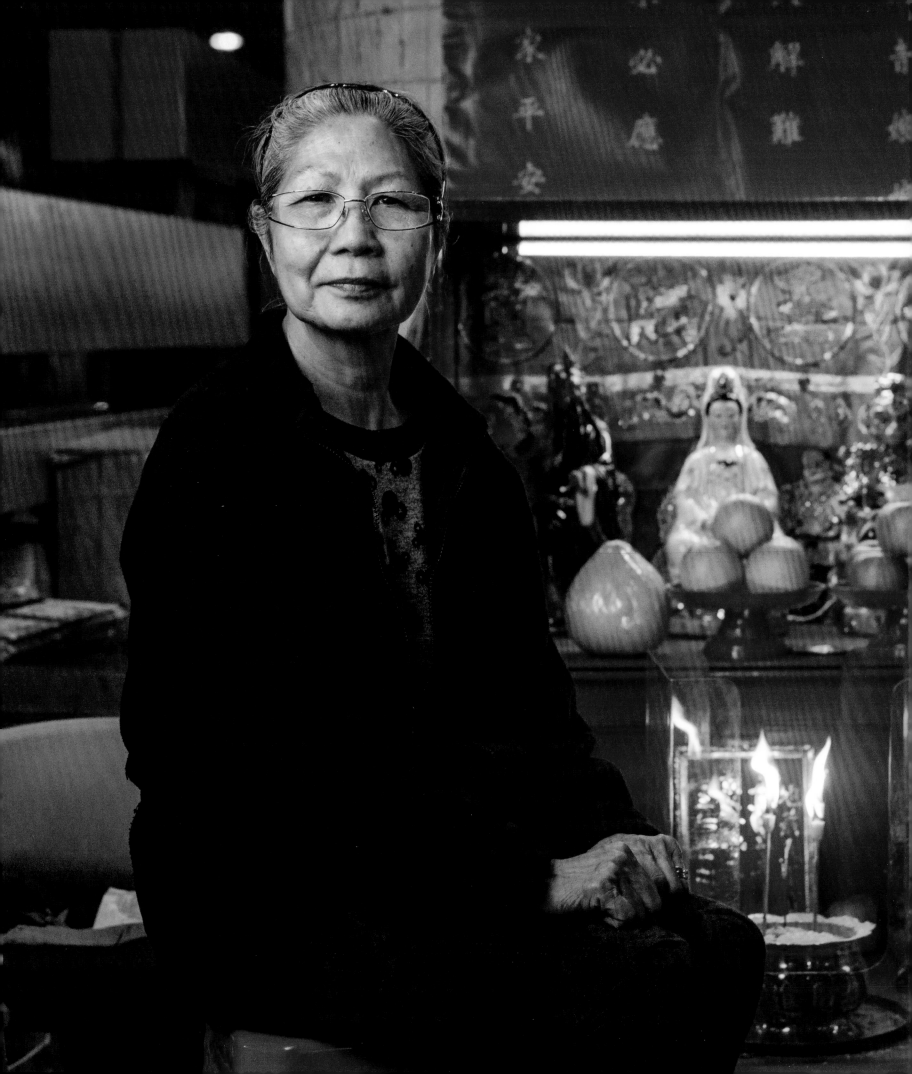

AUNTY YAN 欣姑
VILLAIN HITTER

Amid the hordes of rushing commuters and traffic under the Canal Road bridge sits Aunty Yan, who has worked there as a villain hitter for many years. Her warm, smiley face is a stark contrast to her harsh surroundings. She insists the sorcery is more about helping people to have better luck rather than casting evil curses – although she does that too. In fact, she admits to helping many people seek revenge on cheating spouses or their mistresses, and on cruel employers. Aunty Yan says she has had clients from all over the world, with many returning to request another "hitting". But not every client wants to sit in for the ceremony. She says many people do not want to be seen using her services so they give her the money and the name of their enemy, then stand away from her as she performs the ritual, pretending to wait for the bus.

"I HAD A CUSTOMER WHO CAME TO CURSE HER HUSBAND AND HIS MISTRESS. HOWEVER, SHE ACCIDENTALLY WROTE DOWN HER OWN BIRTHDAY INSTEAD OF HER HUSBAND'S, SO THE CURSE ACTUALLY WENT TO HER."

"I LIKE IT HERE A LOT, THIS IS A VERY TRADITIONAL PLACE IN HONG KONG. MANY TOURISTS SEE IT AS A SIGHTSEEING SPOT AND COME TO EXPERIENCE THE OLD HONG KONG."

THE INDUSTRY

Under a bridge in Hong Kong's buzzing Causeway Bay district sits a gaggle of elderly women at makeshift shrines, shrouded in incense smoke. They are the *daa siu yun* practitioners, or "villain hitters". Originating from China's Guangdong province, this folk sorcery involves beating an effigy of a person or group with a shoe, while chanting incantations such as "hit until your arms break, hit until your legs break". Pork fat is smeared on the mouth of a paper tiger that is then set on fire as a sacrifice to the god Bai Hu, and prayers are made for good fortune. This shadowy underpass of the Canal Road bridge was not chosen by accident. The dark and gloomy area, choked by traffic fumes is a place of very bad feng shui, making it excellent for cursing people.